IMAGES
of America
COMMUNITIES OF
THE KATHLEEN AREA

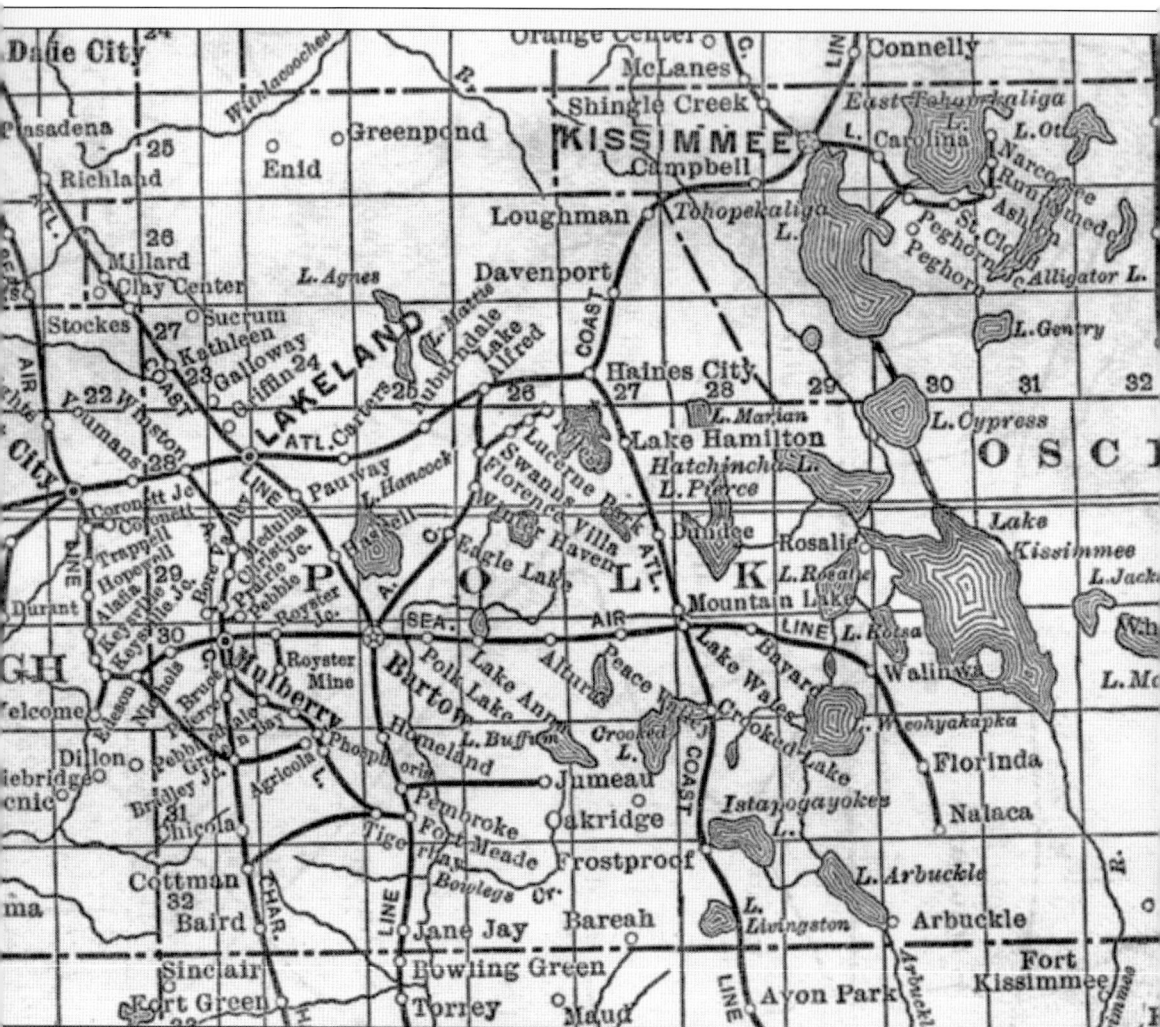

This map depicts Polk County, Florida, in 1920 and includes railroad lines and major cities and towns. The locations of six of the eight communities of the Kathleen area are indicated, including Galloway, Greenpond, Griffin, Kathleen, Sucrum [sic], and Winston. Not shown are Gibsonia and Providence. (Courtesy of Dr. Roy Winkelman, Florida Center for Instructional Technology, College of Education, University of South Florida.)

ON THE COVER: In the spring of 1928, the congregation of Bethel Baptist Church gathered in Socrum to dedicate the new sanctuary, the third structure built adjacent to Indian Pond since the official founding of Bethel Baptist Church in 1863. The well-known redbrick building still stands today as a beacon in the Socrum community and beyond. The sanctuary was used for regular services until 2006, when a new sanctuary was built nearby. (Courtesy of Phyllis Mallory Kendrick Hammond.)

IMAGES of America
COMMUNITIES OF THE KATHLEEN AREA

Lois Sherrouse-Murphy

ARCADIA
PUBLISHING

Copyright © 2015 by Lois Sherrouse-Murphy
ISBN 978-1-4671-1454-7

Published by Arcadia Publishing
Charleston, South Carolina

Printed in the United States of America

Library of Congress Control Number: 2015935751

For all general information, please contact Arcadia Publishing:
Telephone 843-853-2070
Fax 843-853-0044
E-mail sales@arcadiapublishing.com
For customer service and orders:
Toll-Free 1-888-313-2665

Visit us on the Internet at www.arcadiapublishing.com

Dedicated to my parents, Dalton Luther Sherrouse (1917–2007) and Joyce Goodman Sherrouse (1924–2007), who taught me to cherish family and community, and to the residents of the communities of the Kathleen area, past and present.

Contents

Acknowledgments		6
Introduction		7
1.	The People	9
2.	Home Sweet Home	49
3.	Old-Time Religion	59
4.	Book Learnin', Bobs, and Bare Feet	73
5.	The Land's Bounty	93
6.	Mules and Wagons, Velvet Asphalt, and Tin Lizzies	115
About the Organization		127

Acknowledgments

I have always had an interest in history and the good fortune to be raised in the history-rich community of Socrum, as were four generations before me. When we are young, it seems that we take history and good fortune for granted, but the adage "with age comes wisdom" really is true, and eventually, we begin to take notice, ask questions, and appreciate those who came before us. So it is with me. This book offers an opportunity to ensure that the good people and places in the communities of the Kathleen area are known and remembered.

In 2008, I became involved with the Kathleen Area Historical Society and found a home among folks who had already made the journey to wisdom and appreciation of the bountiful heritage of the Kathleen area. I am grateful to the members of the society, who welcomed me, put me to work, became my friends, furthered my education about the pioneers and early lifestyles of the area, and provided many of the photographs that appear in this book.

Friends and relatives also served as amazing sources of history and images, in particular, L. Rabun Battle, Patsy Flora Bridges, Phyllis Mallory Kendrick Hammond, the late Harvey Lanier (1923–1998), Patrick Lombardi, Ruth Anne Witter Maloy, and Robbie Miller. I also acknowledge the encouragement received from fellow Images of America authors Bob Grenier and William Lloyd Harris, who were early supporters of the story being told, and Florida folklorist Bob Stone. The amazing Dorinda Morrison-Garrard, senior library assistant at the Polk County History Center, frequently stumbled upon helpful and informative news articles that she was quick to share. *Kathleen and Nearby Residents, 1920–1940* by Harry Otis Prine (1916–1996) and *Our Goal Is Souls: The History of Bethel Baptist Church* by Arlene Costine Alford (1930–2013) were also invaluable resources. My admiration and appreciation is extended to author Canter Brown Jr. for providing the big picture about the early days of Polk County in his book *In the Midst of All That Makes Life Worth Living: Polk County, Florida, to 1940*. To the late Betty Ann Williams (1920–2015), a founder of the Kathleen Area Historical Society, you were right! Betty Ann gifted me with voluminous folders of newspaper clippings and family histories several years before she passed with the comment, "you need to know this stuff."

Thank you to the members of my immediate family who are a constant source of understanding and encouragement, including my husband, Lamarr; brothers Gerald, Dayton, and Kenneth; niece Esther Sherrouse-Harvey; and nephews Kendal and Kristopher Sherrouse.

INTRODUCTION

The term "Kathleen area," used to describe the eight northwest Polk County, Florida, communities that are the subject of this book, was used for the first time in 1991, with the formation of the Kathleen Area Historical Society. The eight areas are Galloway, Gibsonia, Green Pond, Griffin, Kathleen, Providence, Socrum, and Winston. While the term "Kathleen area" is relatively new, the communities have a long history. In 1824, the post of United States surveyor general for the Territory of Florida was established to survey the public lands in Florida using a township and range system. Shortly after Florida achieved statehood in 1845, federal government surveyors arrived in the Kathleen area communities, and surveys were completed by 1850, well in advance of the establishment of Polk County in 1861.

With surveys completed and lured by the promise of land, a limited number of especially courageous and adventurous pioneer settlers began arriving in the 1840s, primarily from Alabama, Georgia, and the Carolinas, spurred by the federal government's Armed Occupation Act of 1842 and other land incentive programs that followed. The interior portion of the state that houses the Kathleen area (in the region now known as Central Florida) was considered a part of South Florida at the time and was populated mostly by scrub cattle, mosquitoes, and Seminole Indians. The effort to open up the interior of the Florida Territory to white settlers had originally begun with the Indian Removal Act of 1830, and the Armed Occupation Act was another effort at removal, resulting in three Seminole wars. As settlers pushed into the state, it was common practice for interrelated families to travel together, and many families stopped in a settlement known as "Alligator" (now Lake City in Columbia County) for months or several years before finally moving south into the unsettled interior of the state.

In 1861, settlement in the communities of the Kathleen area was interrupted by the Civil War. Men were pressed into service, many local Confederates with the Cow Cavalry, a special battalion charged with procuring cattle to feed the Confederate army. Women and children were left to sustain the home front for months at a time.

While it can be said that the times were simpler then, the living was certainly not easy. Pioneers initially endured harsh wilderness conditions and isolation. Neighbors were few and far between, scattered across Polk County's vast land area of 2,000 square miles. A lack of roads and means of transportation, except by horse and wagon, limited travel to an extremely small area by today's standards. In 1867, Polk County's population was reported at only 1,500 residents. Nevertheless, determined and resilient settlers focused on building homes, schools, and churches and establishing an agricultural-based economy with industries like cattle, citrus, strawberries and other row crops, logging, and turpentining.

Settlers continued to arrive, attracted by the fertile land, especially the land to be found in the communities of the Kathleen area. Hurricanes and freezing weather periodically affected crops, but the settlers endured. In the 1880s, the railroads also arrived, greatly improving the fortunes of residents engaged in agriculture by offering transportation options and employment.

Between 1881 and 1891, 2,566 miles of railroad began operating in the state. The main line of the South Florida Railroad (later the Plant system) ran from Tampa to Sanford in 1884, through northwestern Polk County and the communities of the Kathleen area, with depots established at Kathleen and Winston. By 1895, Polk County reported a population of 10,983 residents, a number that swelled to 63,925 by 1925.

The eight communities of the Kathleen area were generally established between 1850 and 1900, due primarily to these factors:

1. The Armed Occupation Act of 1842, which granted 160 acres of land in the unoccupied regions of Florida to any settler willing to bear arms to defend the property for five years.
2. The end of the Third Seminole War in 1858, creating an increased sense of security and available lands through military bounty land grant programs.
3. The Homestead Act of 1862, which allowed settlement of public lands, requiring five years' residence, improvements, and cultivation for only a $15 fee to obtain 160 acres.
4. The coming of the railroads in the 1880s, giving rise to expanded cattle and citrus operations, strawberry and vegetable crops, and the means to ship via rail.

Socrum is the oldest of the eight communities, with settlers arriving in the community in the late 1840s. It was one of the earliest centers of population in not-yet-established Polk County. The accepted boundaries of today's Socrum community were originally much larger, extending westward to an area known as Itchepackesassa, where a trading post existed. As communities like Kathleen, Galloway, and Griffin were established, Socrum's boundaries changed.

With the exception of Green Pond, the eight communities are contiguous. None have well-defined boundaries, so one community flows into another. When it was incorporated in 1914, the town of Kathleen consisted of a well-defined, one-square-mile area. However, most folks who are familiar with the eight areas have a general sense of where one community ends and another begins.

As might be expected, the derivation of community names is also a rich source of the history of the Kathleen area. Galloway, Gibsonia, Griffin, Kathleen, and Winston were named for pioneer families, while Green Pond, Providence, and Socrum honored special places, hopes, practices, or geographical features.

The time frame of this book generally falls between 1850 and 1930, when the eight communities were established and began to flourish, sandwiched between the Seminole Wars and the Great Depression. The images illustrate that the lives of the early settlers centered around family and neighbors, work, church, and school. In this respect, the pioneers were not much different than today's residents who populate the communities of the Kathleen area.

The story of *Communities of the Kathleen Area* is one of hardship, prosperity, tragedy, joy, bad times, and good fortune by a people determined to forge ahead and persevere. Their ups and downs are not unlike those of the people who currently populate these eight communities.

I am often puzzled by those who proclaim that they do not care about "them" when referring to history or the people who came before us. How can that be? The truth is that we, the current residents of the communities of the Kathleen area, will eventually become "them." Everyone has a simple, basic wish to be known and remembered, and everyone has a story. History connects people, and it is through the recording of our story that being known and remembered is accomplished. The story and the people are often connected in surprising and circular ways. It is my hope that this book serves as a way to know and remember the early settlers of the communities of the Kathleen area and will remind readers of the importance of history.

One

THE PEOPLE

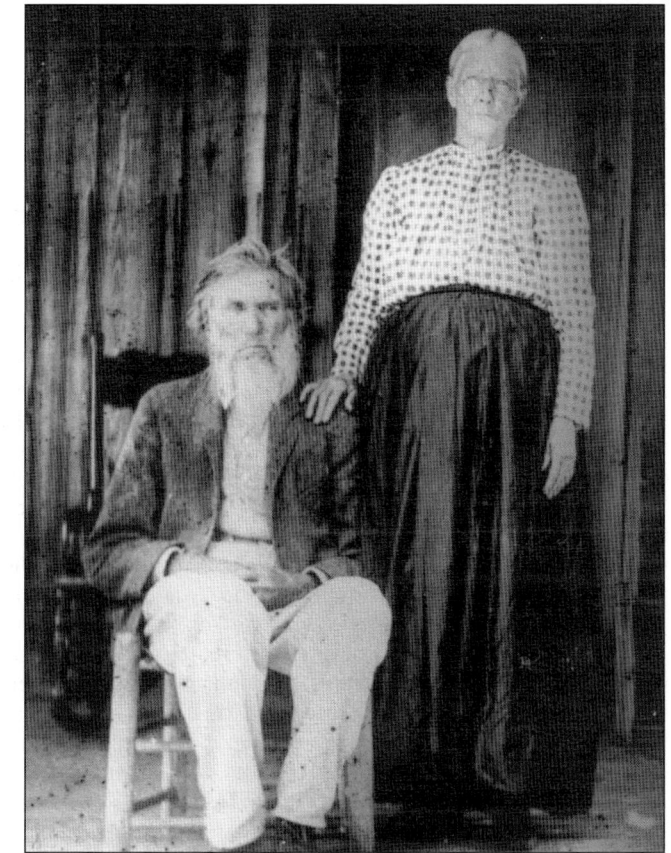

John W. Costine (1829–1922) and Sarah Ann Harris Costine (1829–1916) were typical of the first wave of settlers. The couple migrated to Florida in 1851 from Colleton County, South Carolina, with extended family in tow, first settling in Alligator in Columbia County, Florida, before moving on to Green Pond in 1859. Like many other early settlers, Costine served in the Civil War in Company B, 1st Florida Special Cavalry (commonly known as the Cow Cavalry), which was headquartered near present-day Plant City. He was a cattle raiser and citrus grower and lived to the age of 93. (Author's collection.)

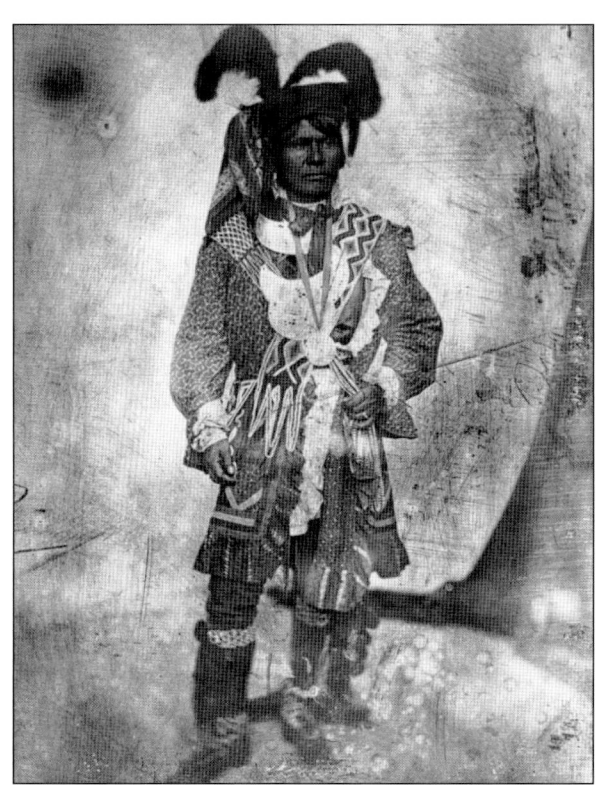

Prominent leaders of the Second Seminole War (1835–1842) and Third Seminole War (1855–1858) who were known to lead Seminole warriors in Polk County were Chief Billy Bowlegs II, left, and Chief Tallahassee, below. The wars were a direct result of white settlers moving into Florida and claiming lands occupied by the Seminole Indians. By 1858, the Seminole population in Florida was reported at less than 200, as many Seminoles were relocated to Oklahoma and the Everglades. (Both, courtesy of State Archives of Florida.)

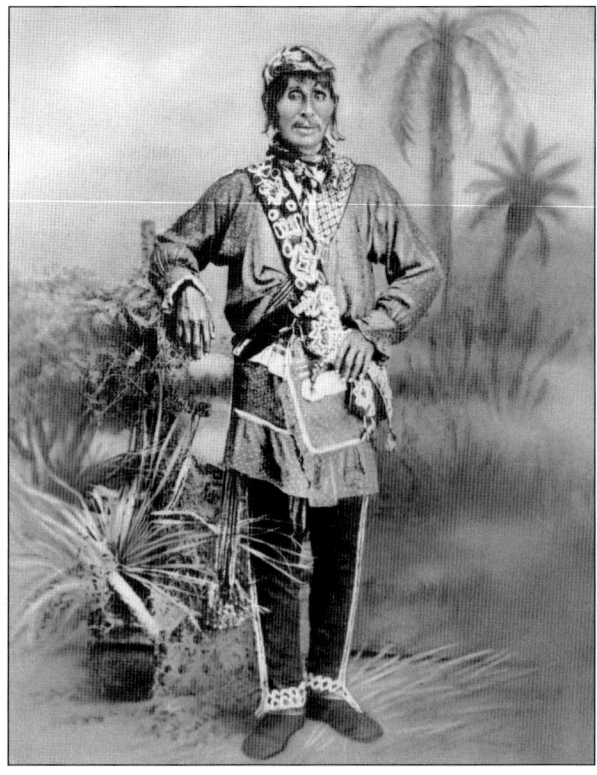

An Army supply depot known as Fort Gibson existed in the 1856–1858 time frame during the Third Seminole War, along the shores of an unnamed lake that later became known as Lake Gibson. The community around the lake was eventually named Gibsonia. Capt. Augustus Gibson (1819–1893) was in charge of the fort, though he served throughout Florida during the Third Seminole War. He was born and raised in the northeastern United States and is interred in Massachusetts. (Courtesy of Brendan Mackie.)

Francis Asbury Hendry (1833–1917) is pictured with a group of Seminole Indians in this undated photograph. He was active in Polk County politics, helping with the formation of the county in 1861 and serving on the board of public instruction and as a state senator. He later moved south to an area that would eventually bear his name: Hendry County. (Courtesy of John L. Hickman.)

11

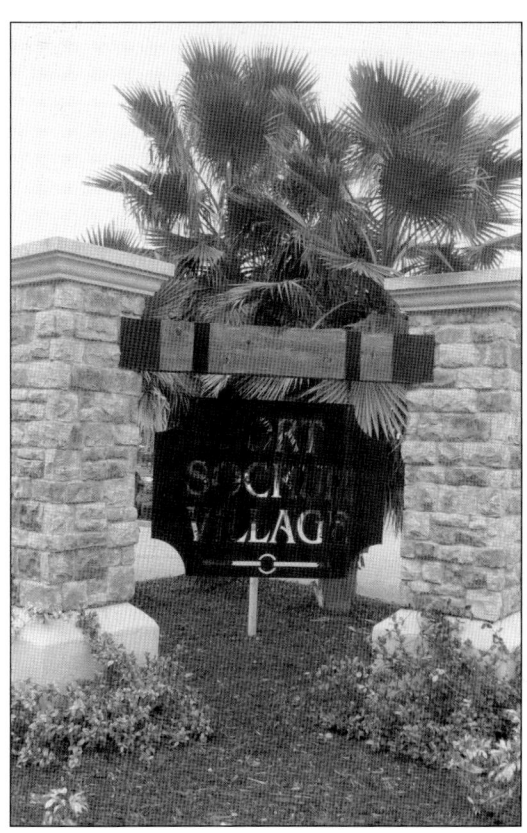

The existence of Fort Socrum during the Third Seminole War has never been conclusively proven through early maps, surveys, or photographs. Stories of the fort's existence persist, however, and have been passed on for many generations. The fort's location is most often noted as being south of Indian Pond, near a creek that fed into the pond at one time. Today, a nearby subdivision is known as Fort Socrum Village, ensuring that the story of the fort's possible location lives on. (Author's collection.)

The marriage of Enoch Everett Mizell (1841–1902) and Martha Bryant Mizell (1848–1904) in 1864 merged two Socrum/Providence area pioneer families. In addition to serving in a militia unit during the Third Seminole War and in the Civil War, Mizell served in several positions of leadership within early Polk County government in the 1860s and 1870s, including county commissioner, tax collector, property appraiser, and sheriff. Both Mizells are interred at Socrum Cemetery. (Courtesy of Mae Wilder Wiggins.)

Stephen T. Hollingsworth (1825–1903) and his wife, Sarah Pearce, settled in the Galloway/Griffin area in the 1850–1880 time frame, according to federal land patents granted during this period for land near present-day Knights Station and Sleepy Hill Roads. Hollingsworth fought in the Seminole wars and also served the Confederacy in the Civil War. His brother John Henry Hollingsworth settled for a brief time in Lakeland on the shores of what came to be known as Lake Hollingsworth. From left to right are (seated) Sarah, Jane Angeline, Joseph L., and Stephen; (standing) Martha, Henry, Joshua, and Thomas Enoch. Joshua Hollingsworth was the first president of Florida Southern College (1886–1888) before the college moved from Leesburg to Lakeland in 1922. Stephen and Sarah Hollingsworth are interred at Griffin Cemetery. (Courtesy of State Archives of Florida.)

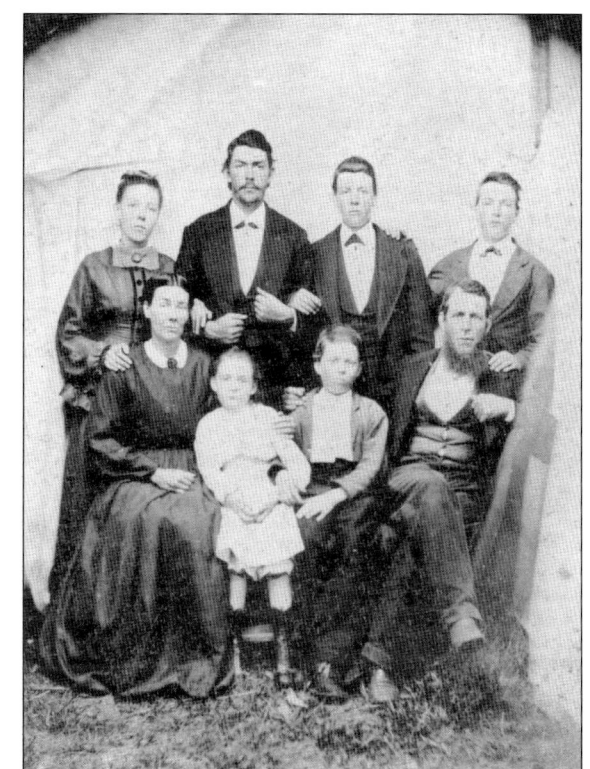

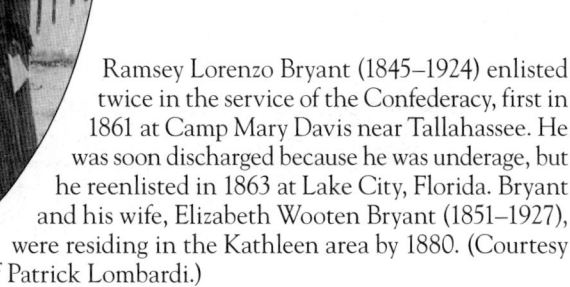

Ramsey Lorenzo Bryant (1845–1924) enlisted twice in the service of the Confederacy, first in 1861 at Camp Mary Davis near Tallahassee. He was soon discharged because he was underage, but he reenlisted in 1863 at Lake City, Florida. Bryant and his wife, Elizabeth Wooten Bryant (1851–1927), were residing in the Kathleen area by 1880. (Courtesy of Patrick Lombardi.)

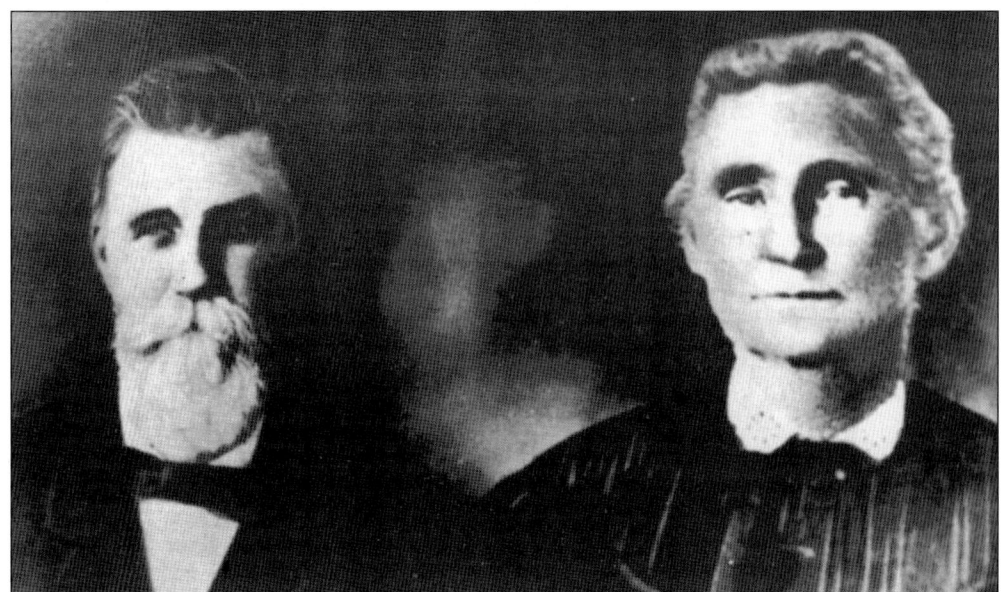

The Rushing family was one of the earliest to settle in the Socrum community. Pictured are James H. Rushing (1848–1929) and his wife, Ardelia Raulerson Rushing (1852–1943). James was a son of William T. Rushing and Belinda Futch Rushing, who settled at Socrum's Indian Pond in the early 1850s. William was slain in February 1857 by his son-in-law during an argument on a return trip from the trading post at Itchepackesassa and was one of the first to be interred at Socrum Cemetery. (Courtesy of Bethel Baptist Church.)

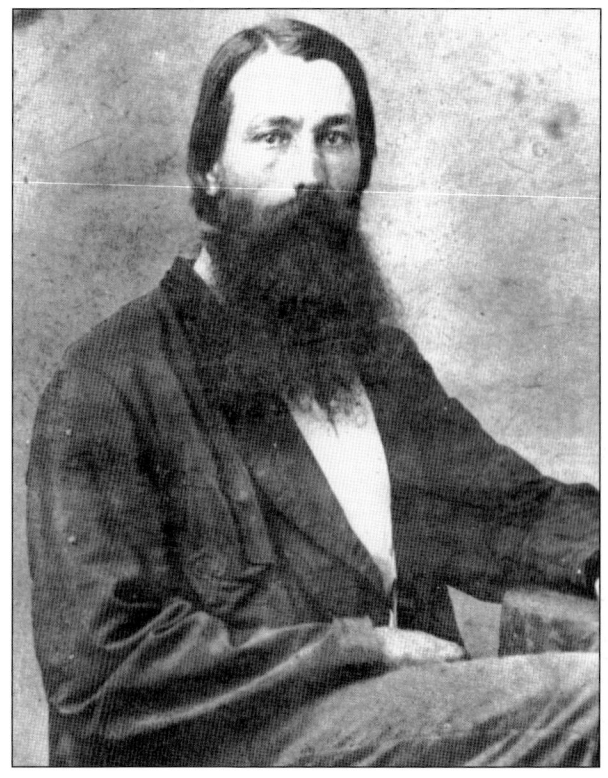

Cpl. Cletus Sherouse settled on Kathleen's Ross Creek Road in 1870 in an area that was known first as Ebenezer, a nod to his Georgia Salzburger ancestry in Ebenezer, Georgia. In 1878, he moved his family to Socrum at the corner of present-day Keen and Sherrouse Roads. Sherouse enlisted in the Confederate Florida Infantry on February 16, 1863, as a corporal at Orange Springs, Marion County. His Confederate pension application indicates that he was "slightly wounded" in the Battle of Olustee near Lake City on February 20, 1864. (Author's collection.)

Pioneer settler Jacob Summerlin had vast land holdings in Polk County, some located in the communities of the Kathleen area. In April 1857, eighty acres of land, originally awarded to Richard A. Vickers as bounty land for military service in the Seminole Wars, was returned to the General Land Office and then "assigned" to Jacob Summerlin. On July 5, 1857, Summerlin presided as justice of the peace for the marriage of Kathleen pioneers Henry A. Prine and Catherine Rogers at Fort Gibson. Though from humble beginnings, Summerlin amassed a fortune in the cattle industry and came to be known as the "King of the Crackers." (Both, courtesy of State Archives of Florida.)

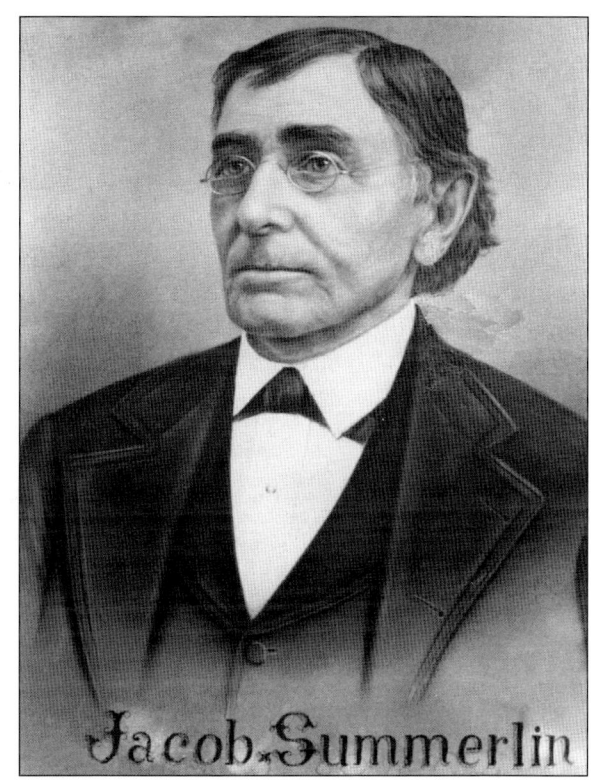

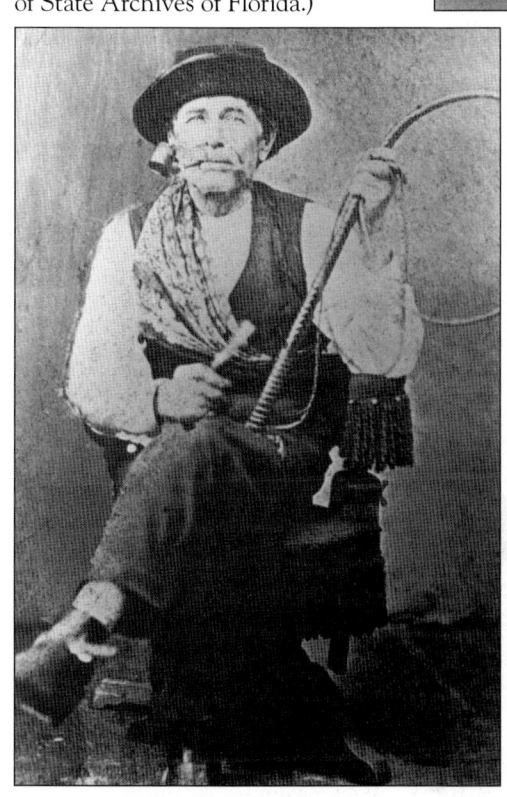

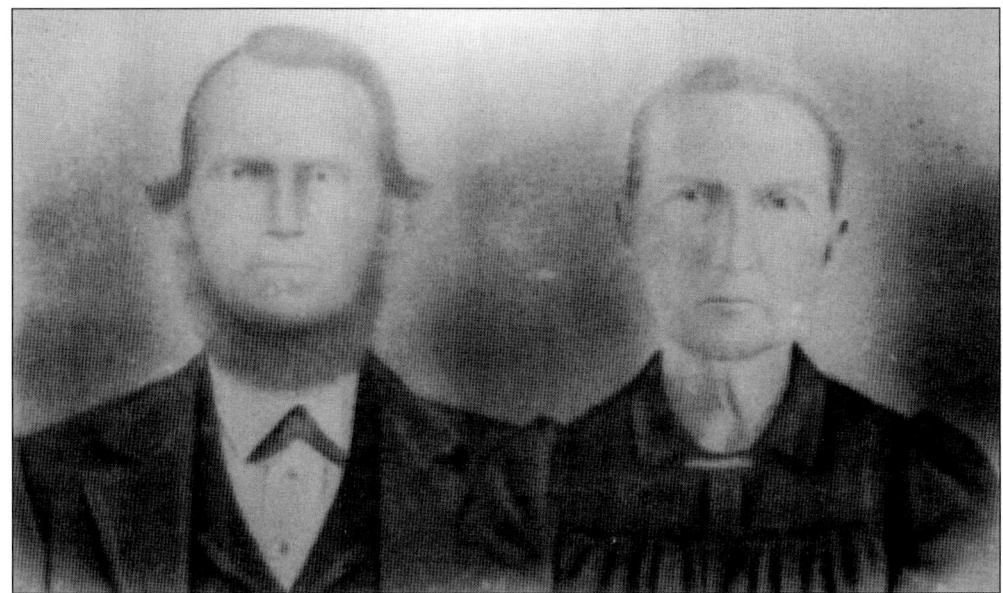

William Henry Hancock was one of the earliest settlers of the Socrum area. In 1857, he was issued a deed by the United States government as bounty for his service in the Seminole Wars. After enlisting in 1861, he also served the Confederacy in the Civil War throughout the southeastern United States. He was furloughed in 1865 after capture and hospitalization. He settled in Socrum with his wife, Calistianne Strickland Hancock, where the couple raised 13 children. (Courtesy of Angela Fenton Slappey.)

The Civil War service of many pioneer settlers in Munnerlyn's Cattle Battalion (the Cow Cavalry) is memorialized on a monument in Plant City. A partial listing of those from the Kathleen area who served include the surnames Bryant, Costine, Cox, Combee, Hancock, Futch, Keen, Lanier, Mizell, Prine, Raulerson, Sloan, and Wilder. The battalion was formed in 1863 and was charged with rounding up cattle to feed the starving soldiers of the Confederacy. (Author's collection.)

The appearance of Francis C.M. Boggess (1820–1903) in the Socrum community in late April or early May 1865 was a welcome sight. Boggess, who served in a Cow Cavalry unit in Brooksville, reportedly brought news of the Civil War's end to a revival meeting in progress at Bethel Baptist Church. (Courtesy of State Archives of Florida.)

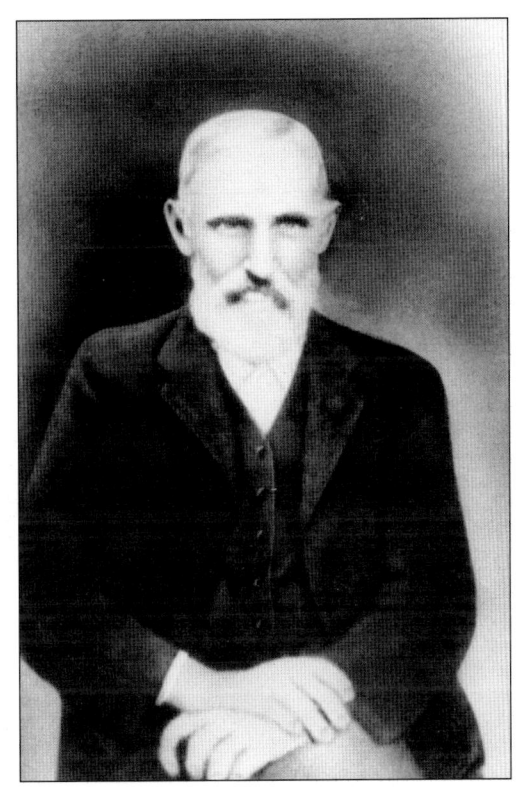

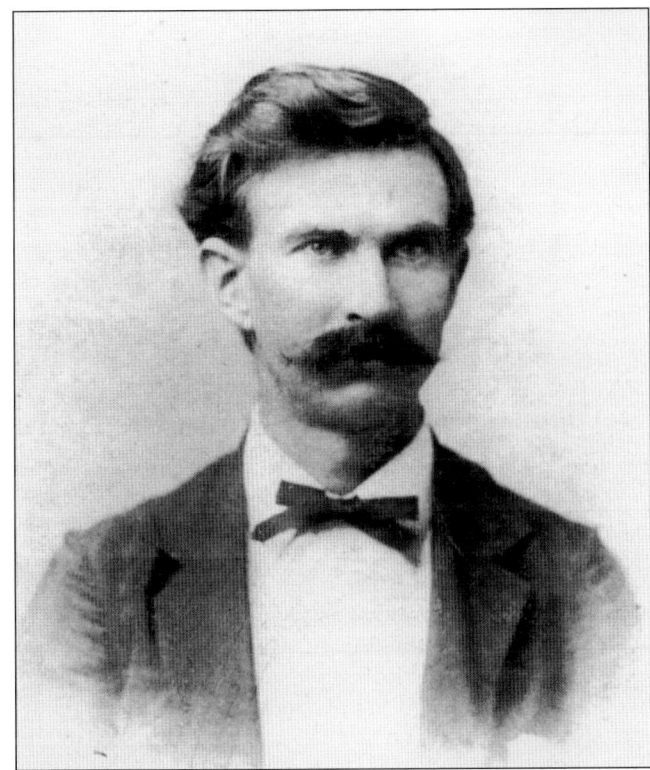

D.H. Sloan Sr. was born in Socrum in 1864. In 1886, he married Ruby Wilder, daughter of E.G. and Cornelia Hendry Wilder. Sloan represented Polk County in the Florida House of Representatives in 1899 and then in the Florida Senate in 1909, 1911, and 1912. The Sloans were instrumental in the completion of the Bethel Baptist Church sanctuary in 1928–1929. Both are interred at Socrum Cemetery. (Courtesy of Bethel Baptist Church.)

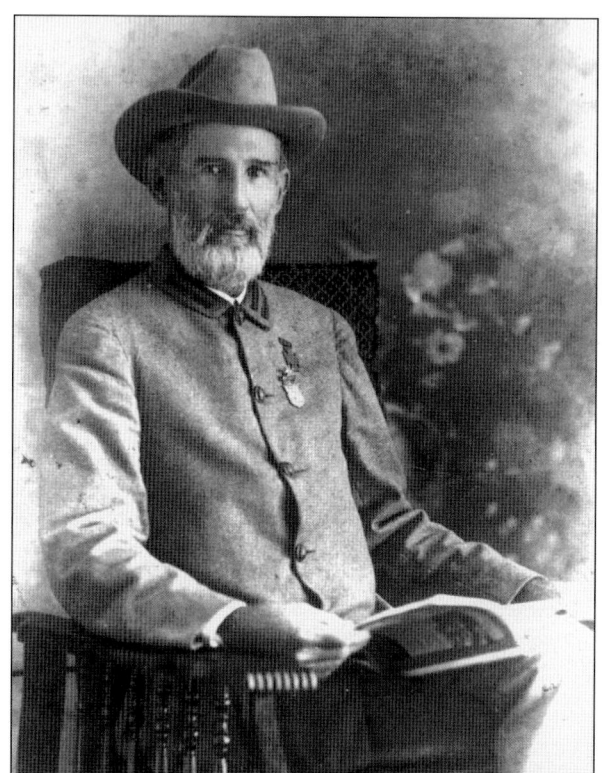

Edward Gross Wilder (1847–1912) and his wife, Cornelia Alice Hendry Wilder (1849–1938), arrived in the Socrum area in the mid-1860s, after Wilder's service in a Cow Cavalry unit in the Civil War. Wilder and his wife were active in Bethel Baptist Church and were baptized by Rev. J.M. Hayman in 1864. According to a history of the church, Wilder preferred to live in the Socrum area because of the good water, health, and fertile soil, and he also noted that he never had a total failure of crops. (Courtesy of Bethel Baptist Church.)

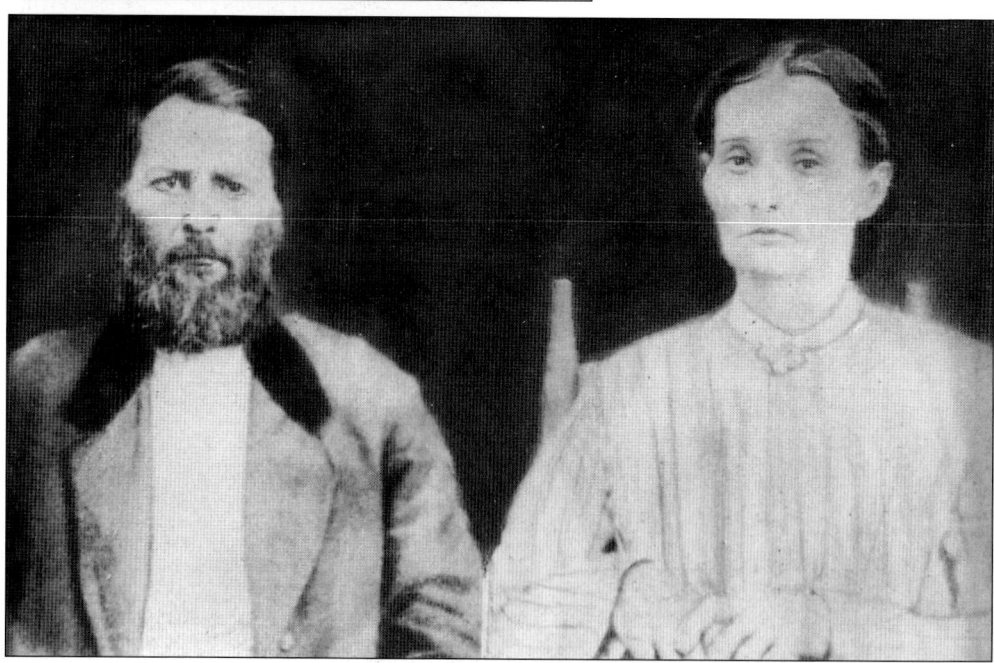

After enlisting in the Confederate army in Alachua County, John E. Gavin (1823–1907), his wife, Mahala Grantham Gavin (1833–1918), and family moved to Hillsborough County in 1870. In 1880, the family settled in the Socrum/Kathleen area on Campbell Road, where he acquired 160 acres of land in 1884. (Courtesy of L. Rabun Battle.)

In 1882, Henry B. Plant (1819–1899) formed the Plant Investment Company, headquartered in Sanford, and began acquiring small railroads like the South Florida Railroad, which was active in the Kathleen area at a place called Ebenezer Church. By 1884, he connected existing lines and built new lines between Sanford and Tampa and other areas throughout the eastern seaboard. The system of rail lines allowed agricultural-based industries such as cattle, citrus, logging, phosphate, strawberries, and other row crops to flourish, with mass transportation of these goods to customers in areas outside Florida. The Plant system was the most profitable transportation network in Florida during the 1880s and 1890s and included steamships and hotels, bringing tourism and population growth. (Both, courtesy of State Archives of Florida.)

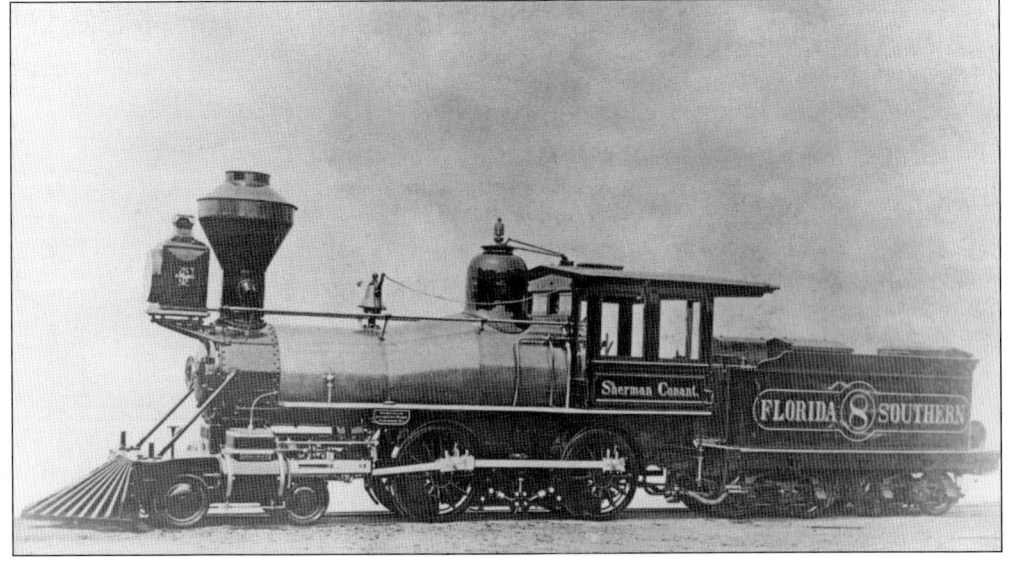

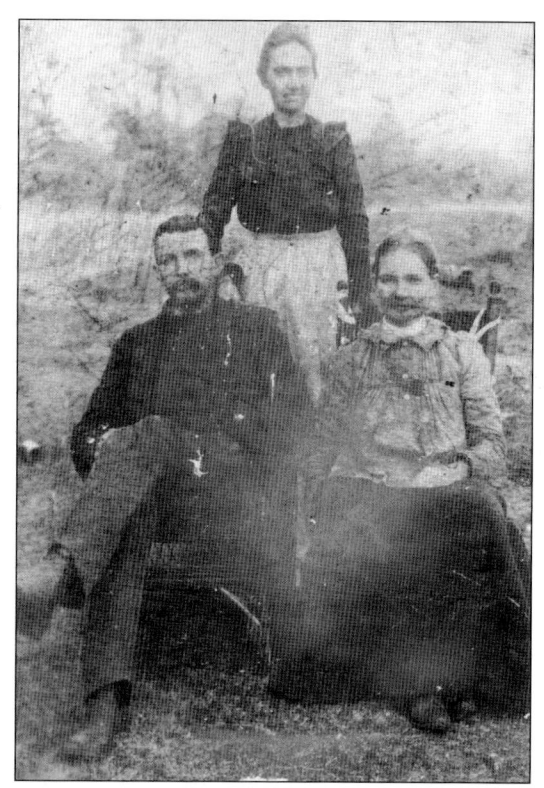

The Winston and Bone Valley Railroad was an early rail line established by William Mills Winn and his business partner, J.D. Griffin, to serve the pair's lumber mill, known as Griffin's Mill. In 1892, the Plant system acquired the short rail line and linked it to the booming phosphate industry in the southern part of Polk County. The communities of Winnston (later Winston) and Griffin are named for them. Seated are William Mills Winn (1857–1915) and his wife, Fannie Stephenson (1866–1918). Standing is Nancy Winn, sister to William Mills Winn. (Left, courtesy of City of Lakeland Library, Special Collections; below, courtesy of State Archives of Florida.)

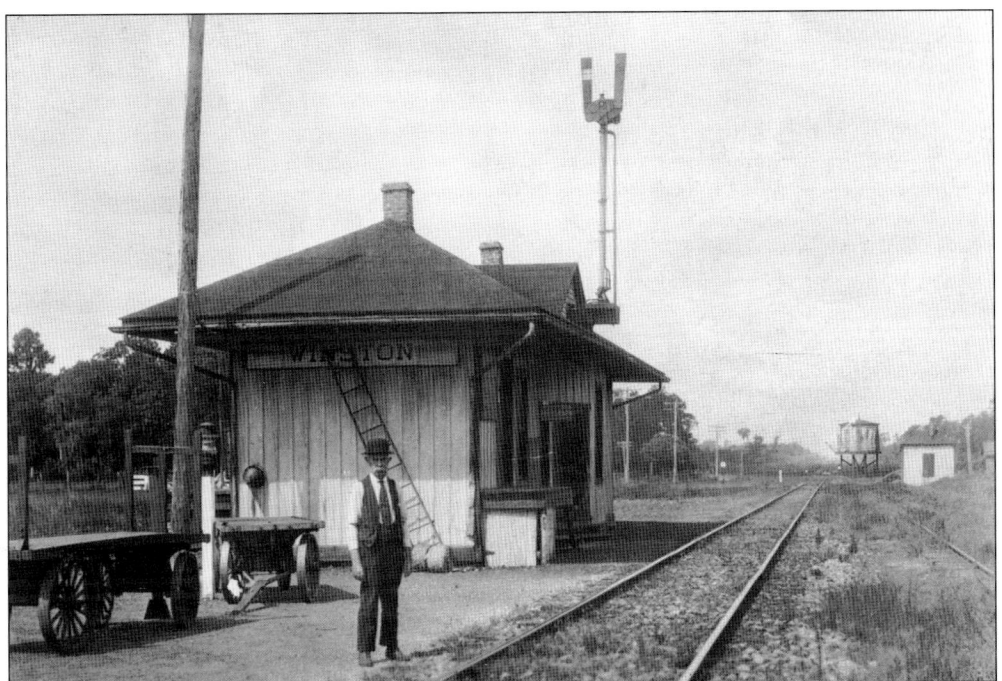

The Winston Depot is pictured around 1920. The depots at Winston and Kathleen were especially busy during the early 1900s. (Courtesy of State Archives of Florida.)

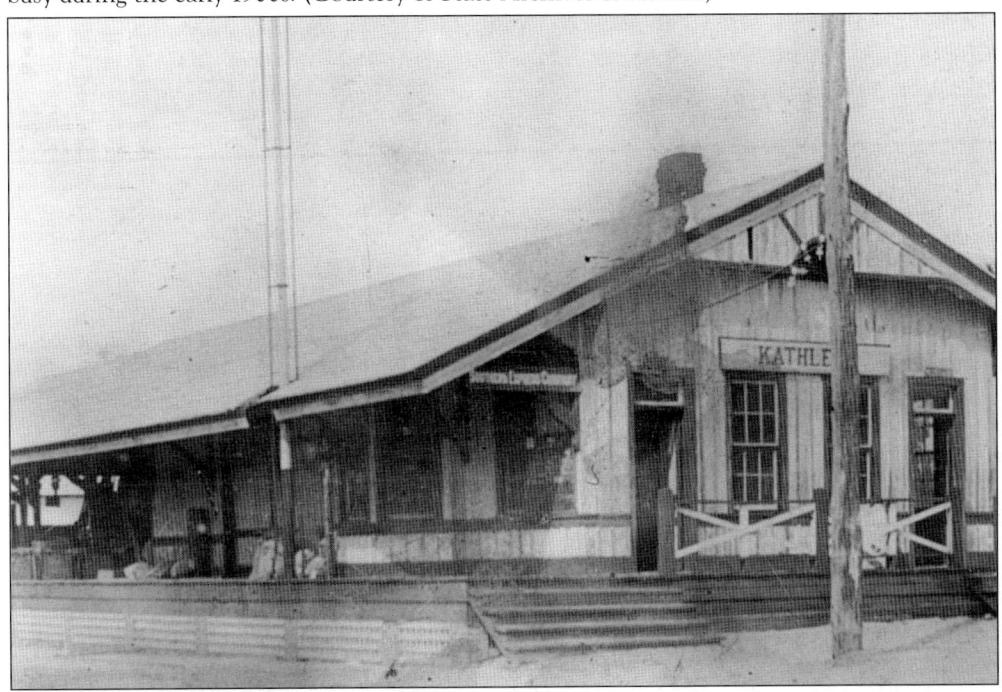

The Kathleen Depot was in operation from around 1888 to the late 1930s. The depot was established after Henry Prine provided land for it. In addition to providing a point of shipment for strawberries, the depot was also a gathering spot for the town's residents and encouraged travel outside the immediate area. (Courtesy of City of Lakeland Library Special Collections.)

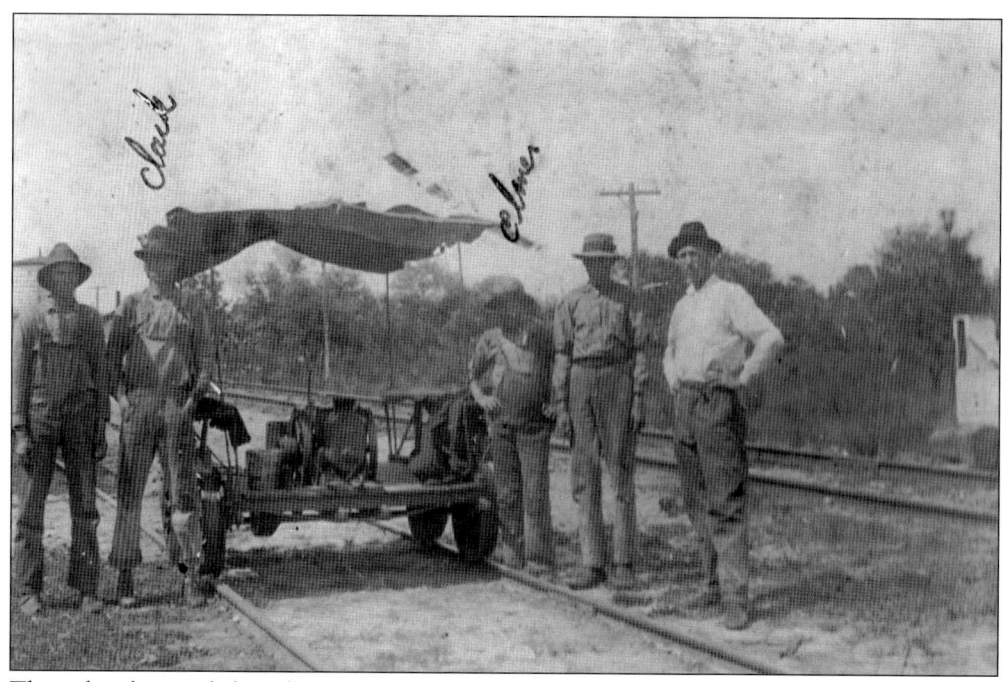

The railroads provided employment to many area residents, like this group of young men. Brothers Clark Gavin (1895–1958) and Elmer Gavin are second and third from the left. (Courtesy of L. Rabun Battle.)

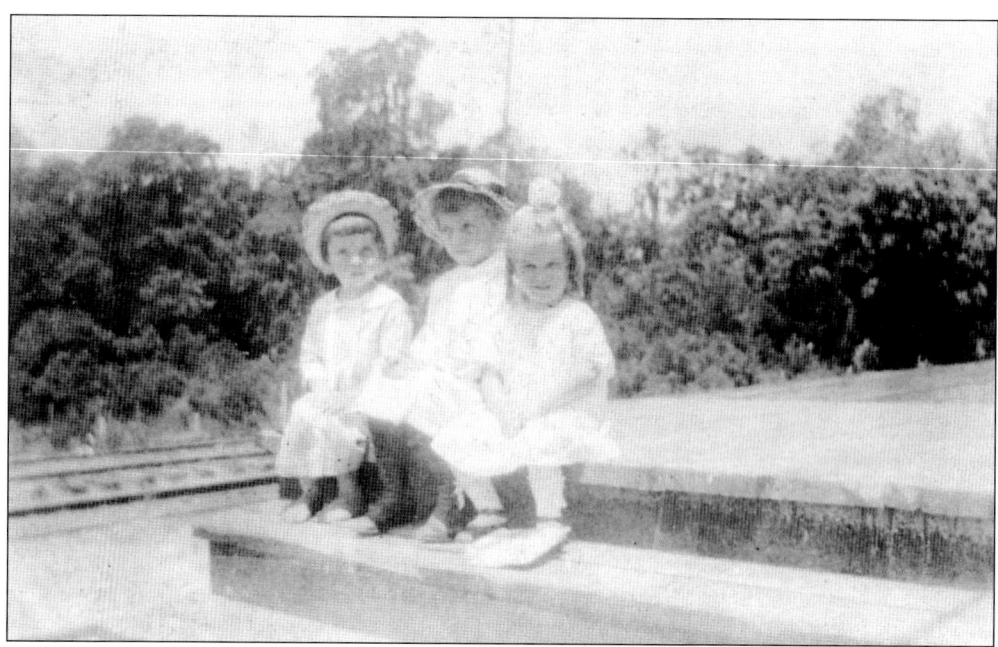

Pictured here are three little girls—Elizabeth Brown (Shumate), Evelyn Brown (Philpot), and Virginia Mosely (Hickman)—sitting on the steps of the Kathleen Depot in 1916, awaiting the train to visit cousins. (Courtesy of John L. Hickman.)

The Kathleen Post Office was established in 1887 and is still in operation today, though not in the original location. Then, as now, the post office served as a place to learn of news and happenings in the community. This photograph was taken around 1903. (Courtesy of Harvey Lanier.)

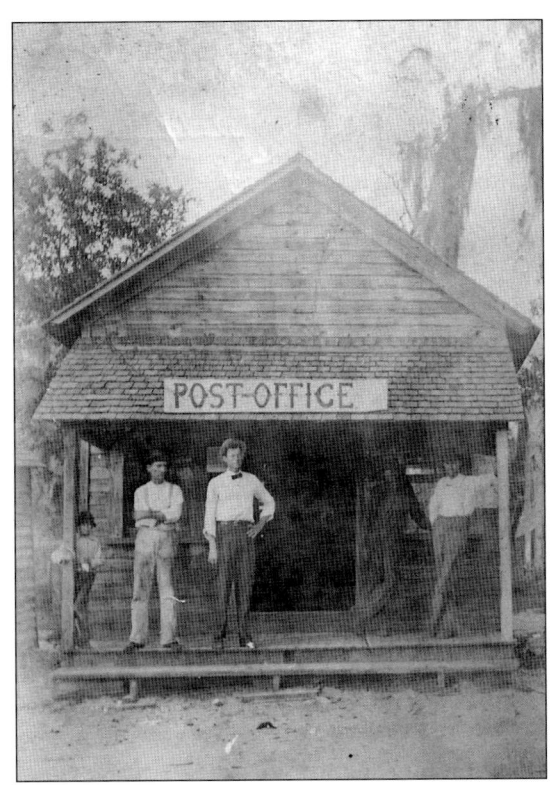

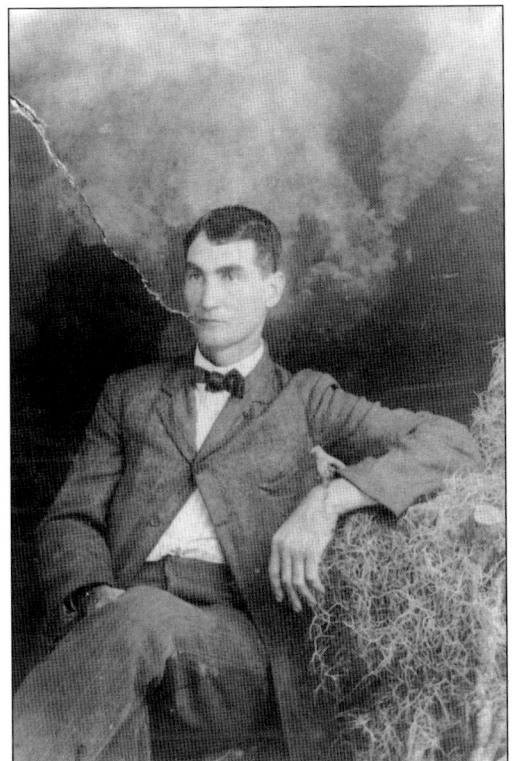

John Levi Jones (1860–1906) served as postmaster for Kathleen before his tragic death on September 26, 1906, after slipping and falling in an attempt to board a train in Tampa. Reports from the *Tampa Tribune* noted that his pocket watch stopped at 8:47 p.m., probably the time that he was struck by the train. He was described as a large man at six-foot-three-inches tall and 200 pounds. The undertaker commented that Jones's corpse was the largest he had ever handled. (Courtesy of Glenn and Patsy Flora Bridges.)

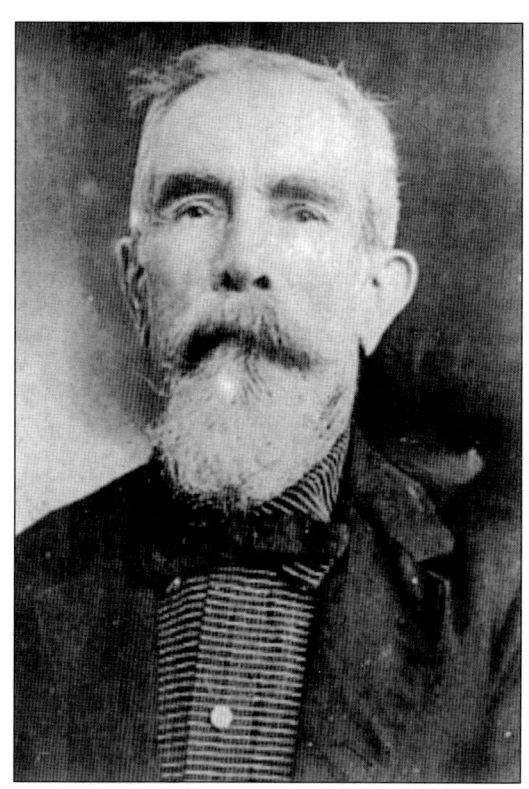

Kathleen pioneer Henry A. Prine (1832–1907) arrived in 1857. By October 1884, he acquired a land patent for 160 acres through the terms of the 1862 Homestead Act "to secure homesteads to actual settlers in the public domain." In the late 1880s, he was given the privilege of naming the town of Kathleen after he provided land for the train depot. He chose "Catherine" in honor of his wife, Catherine Rogers Prine (1842–1916), but the name was changed to Kathleen when it was discovered that another town known as St. Catherine was already in existence in Sumter County. (Both, courtesy of Kathleen Area Historical Society.)

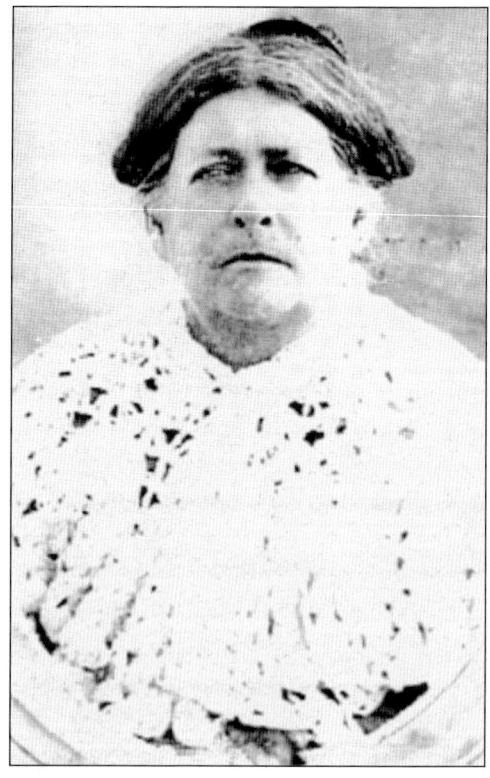

James Henry Rutledge (1875–1943) was elected the first town marshal of Kathleen at a meeting held at the "Depot Shed" after the town was incorporated in August 1914. Twenty-nine named residents attended the meeting, exceeding the requirement that 25 persons who were "qualified voters" be in attendance. In addition to Rutledge, other town officers elected at the meeting were A.S. Keith, town clerk, and W.A. Casebier, mayor. (Author's collection.)

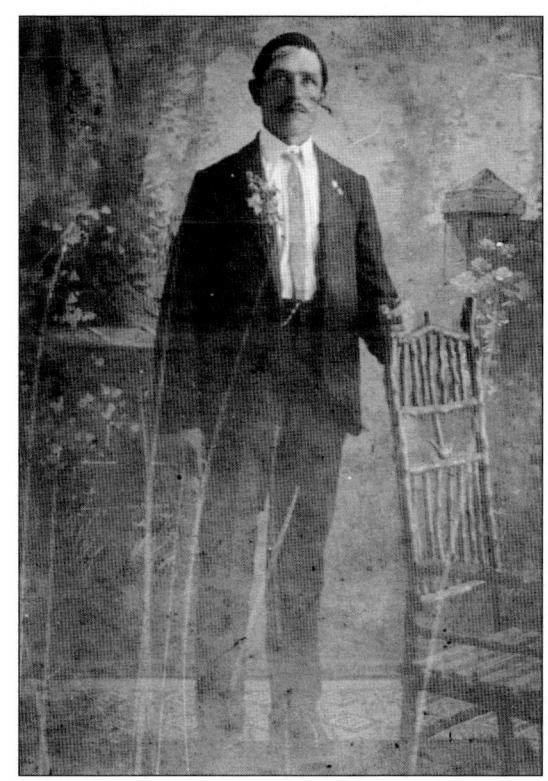

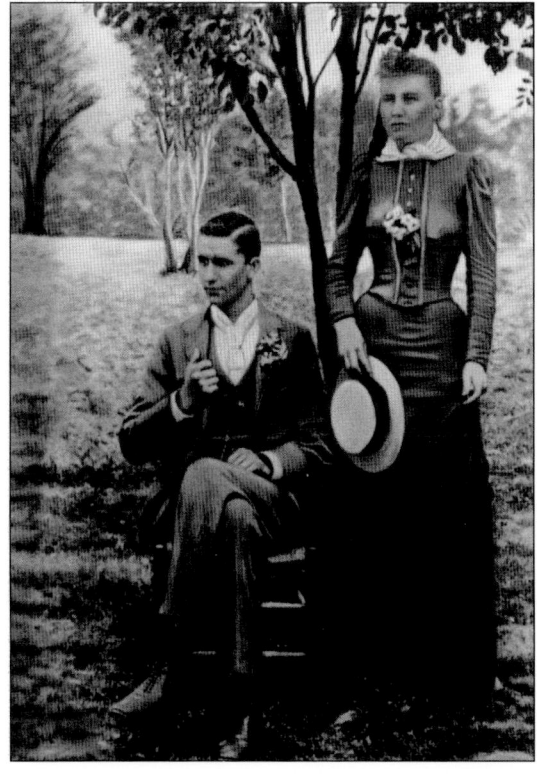

William Asbury (1873–1945) and James Leonard Grace "Lennie" Ross (1876–1935) settled on Ross Creek Road in the early 1900s. Ross was elected as an alderman for the town of Kathleen when it was incorporated in 1914. (Courtesy of Clara Ross Melton family.)

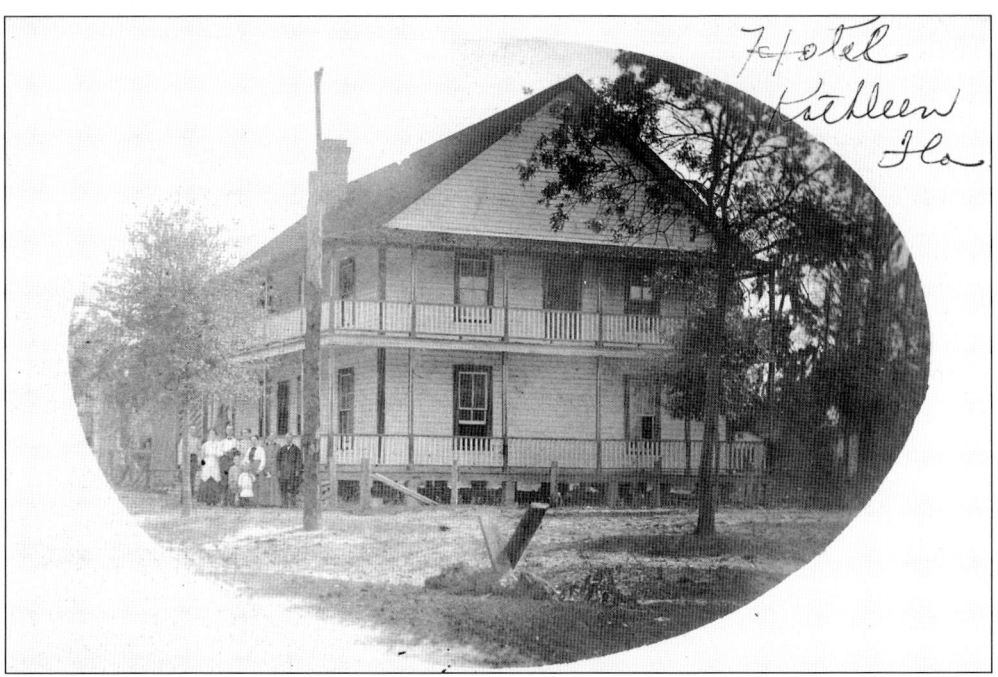

At its most prosperous, the town of Kathleen had nine general stores, a drugstore, three doctors, a post office, a train depot, a barbershop, a blacksmith shop, a filling station, a jail, a school, a repair garage, a realty company, a sawmill operated by Strickland Lumber Company, two churches, three hotels/boarding houses (one of which is pictured above), and a fruit-and-vegetable exchange, pictured below. The 20-room Kathleen Hotel was destroyed by fire in August 1917. (Above, courtesy of Phyllis Mallory Kendrick Hammond; below, courtesy of Kathleen Area Historical Society.)

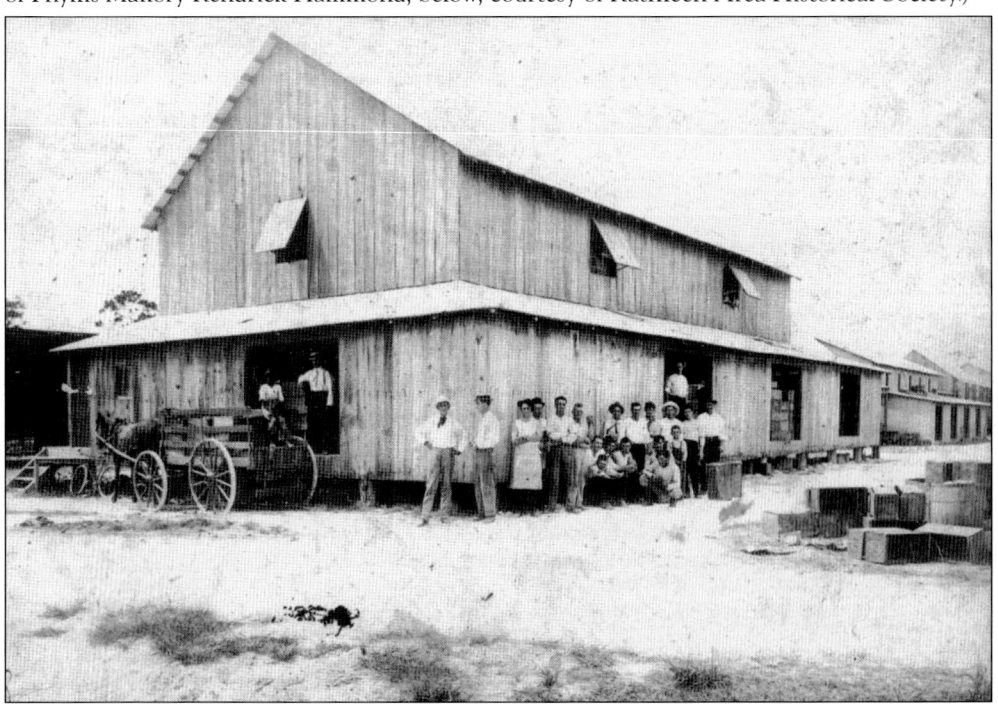

In December 1910, a booklet written by the Polk County Commission touted the benefits of life in Kathleen, calling it "one of the most important strawberry-growing stations in this section of the state. At Kathleen, you will find good stores and all the conveniences of a small town. In selecting a place to locate in south Florida, you will make a mistake if you do not visit Kathleen." Pictured are Sylvia and Sara Holbert. (Courtesy of L. Rabun Battle.)

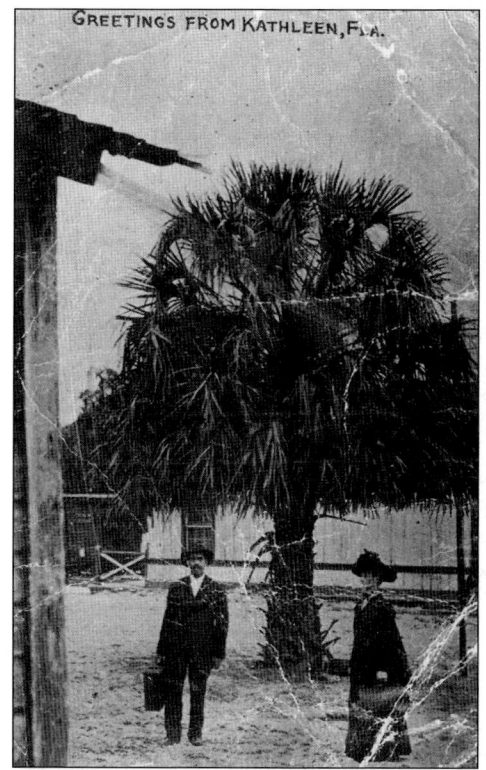

Photographs were often made into postcards to share greetings or news of prosperity, like this postcard from Kathleen in 1915. In the August 9, 1923, issue of the *Lakeland Star-Telegram*, the Kathleen Chamber of Commerce advertised that there were six passenger trains daily and that "Kathleen's rich dark loamy farms respond bountifully and create a constant source of wealth." The Kathleen Depot is in the background. (Courtesy of L. Rabun Battle.)

Hilda Gavin Battle (1922–2001) was the daughter of Kathleen pioneers Clark and Celeste Lovejoy Gavin. As a toddler, she sported a fancy hat, perhaps practicing for the nurse's cap she would wear in her adult career. She was one of the founders of the Kathleen Area Historical Society in 1991. She is pictured below (in front) a few years later, with cousin Vivian Gavin Hampton Ottinger. (Both, courtesy of L. Rabun Battle.)

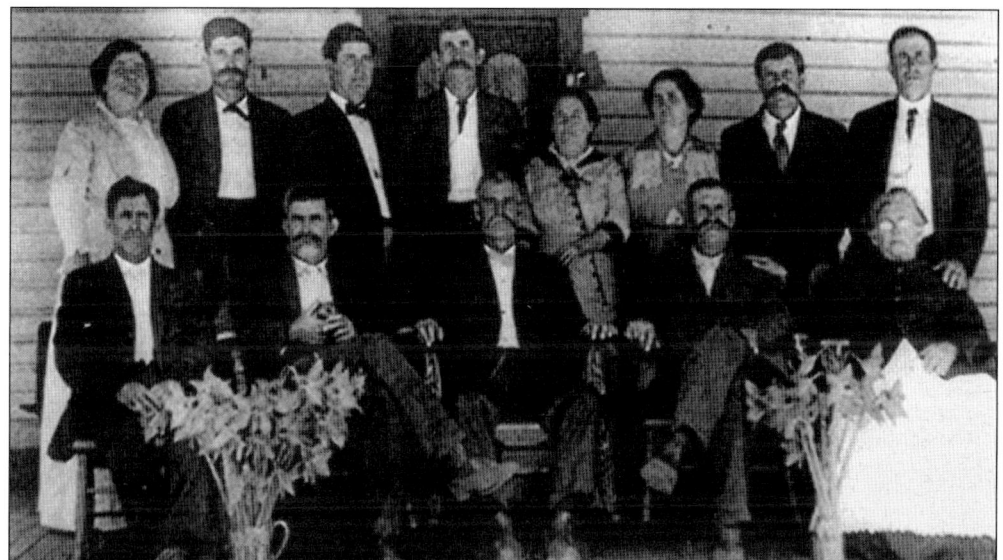

Large families were standard for many pioneer settlers in the Kathleen area. Pictured are Catherine Rogers Prine (1842–1916) with 12 of her 14 children. This photograph is believed to have been taken in August 1907 at the funeral of Catherine Prine's husband, Henry Alfred Prine (1832–1907). From left to right are (first row) Shelton, Morgan, Robert, Thomas, and Catherine; (second row) Martha "Mattie," Henry Bloxham "Block," Leon, Dallas, Anne, Margaret, Lawson, and John Charleston "Chart." Missing from the photograph are Ellen and Helen. (Courtesy of Mary Katherine Walker North.)

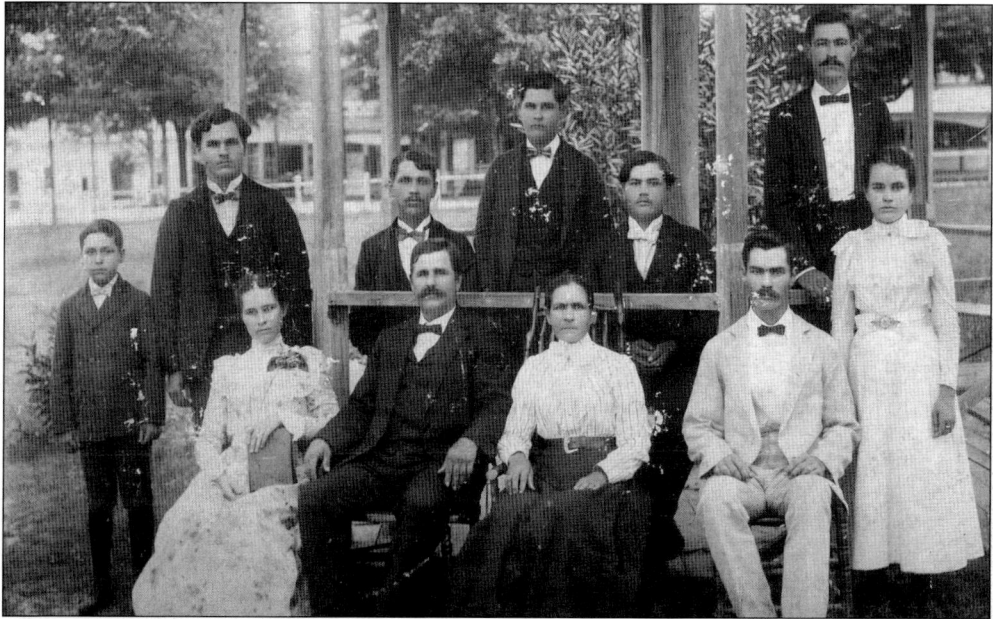

The James W. Lanier family is pictured around 1900 in downtown Lakeland's Munn Park. Lanier operated a grocery store in Kathleen, while his son John W. Lanier operated a store in Lakeland. From left to right are (seated) Mary Lanier, James W. and Sarah Sherouse Lanier (patriarch and matriarch), and Henry Lanier; (standing) Cleve Lanier, Willoughby Lanier, James C. Lanier, Lewis Lanier, Dallas J. Lanier, John W. Lanier, and Susan Lanier. (Courtesy of Harvey Lanier.)

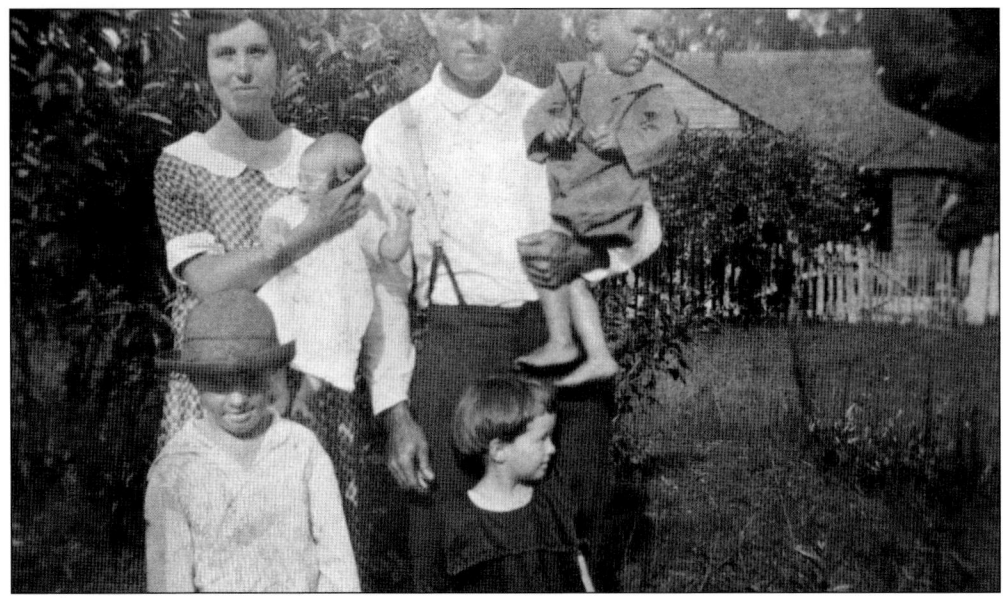

By the 1920s, a fourth generation of pioneer families was still living in the area, like Luther Langley Sherrouse and his wife, Ollie Costine Sherrouse, pictured here with four of their eight children. The two children in front are Dalton Sherrouse (1917–2007) and Genevieve Sherrouse Wyatt (1919–2007). In the arms of their parents are Earl Sherrouse (1923–2004), left, and Denver Sherrouse (1921–2002), right. (Courtesy of Janet Perrone Cromas.)

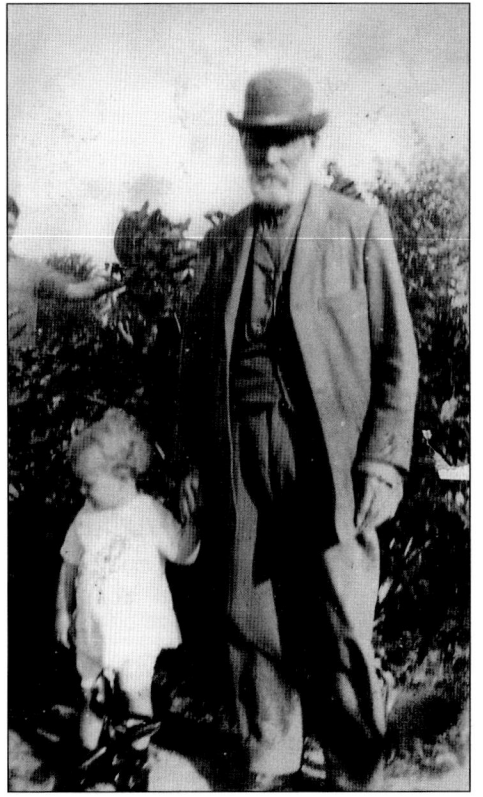

Dr. James Appleton Chapman (1835–1935), pictured with great-grandson Herbert Earl Buckley, migrated from Alabama in 1882 and originally settled in the Medulla area, south of Lakeland, after having served as an infantryman and physician in the Confederate army during the Civil War. His house calls to citizens in the Griffin area resulted in his relocating to the Griffin community because he liked the area so well. He died at age 100 in 1935 and is interred at Griffin Cemetery, which he helped to establish. (Courtesy of Gracia Thompson Krug.)

Twins Mae Wilder (Wiggins) and Faye Wilder (Smith) joined big brother Edgar Wilder (1915–1963) and father, Edward T. Wilder (1870–1931), around 1919 in front of the family car. Wilder and his wife, Ida Mizell Wilder (1876–1956), were married in 1896 and lived in the Providence area on present-day Wilder Road. The three children pictured here were the last three children born in a family of eight children. Of his pretty twin girls, Wilder said, "I wouldn't take a million dollars for these two, but I wouldn't give a nickel for two more." (Courtesy of Melba Roberts.)

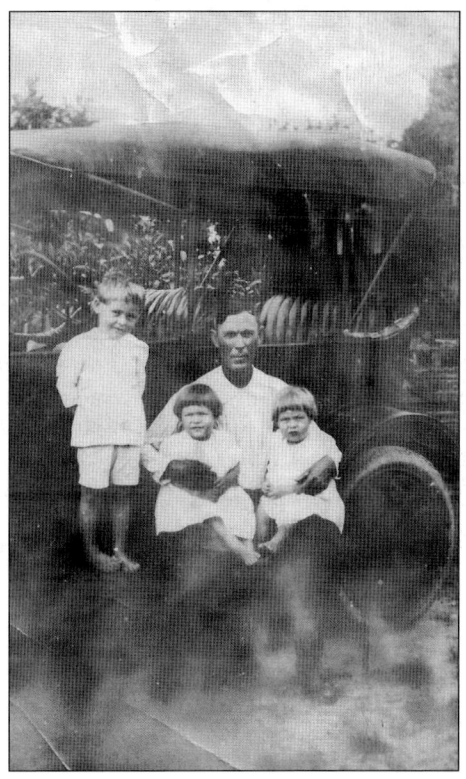

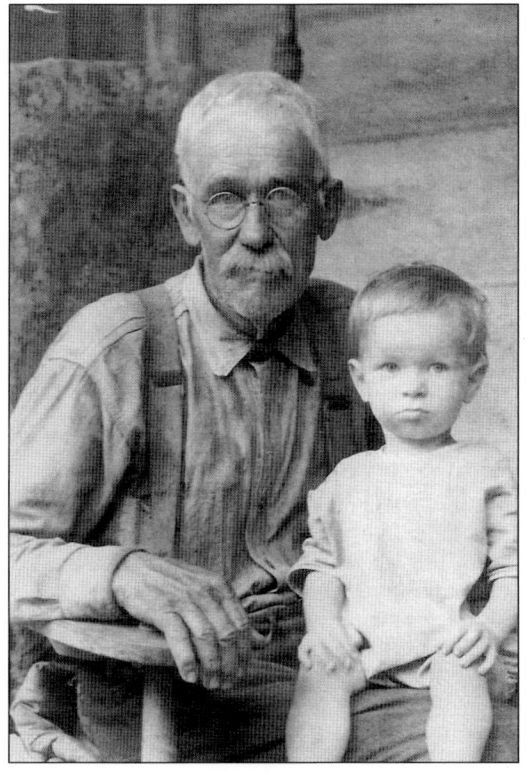

Socrum resident John C.F. Witter (1858–1953) was a lifelong resident of Socrum, and his descendants still live in the area. He is pictured with his grandson Grady Witter around 1925. (Courtesy of Ruth Witter Maloy.)

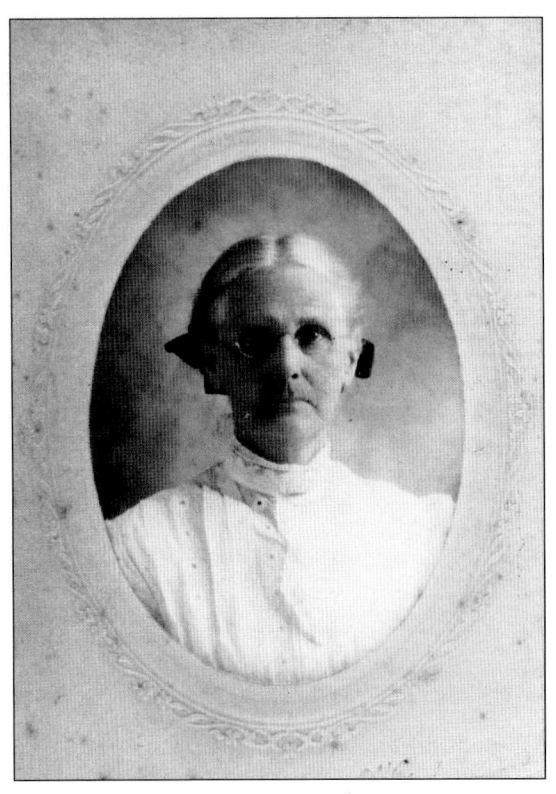

Around 1873, A.T. Williams arrived in the area that became known as Green Pond. He migrated from Green Pond, South Carolina, and is credited with naming the settlement of Green Pond, Florida, because it reminded him of where he was born and spent his early years. With him was his wife, Pencheeta Handcock Williams (1849–1924), and their four children. Five more children were born once the family settled in Florida. Williams was a charter member of Green Pond Baptist Church in 1894 and also served as the settlement's undertaker. (Both, courtesy of Sharon Kenyon Meeks.)

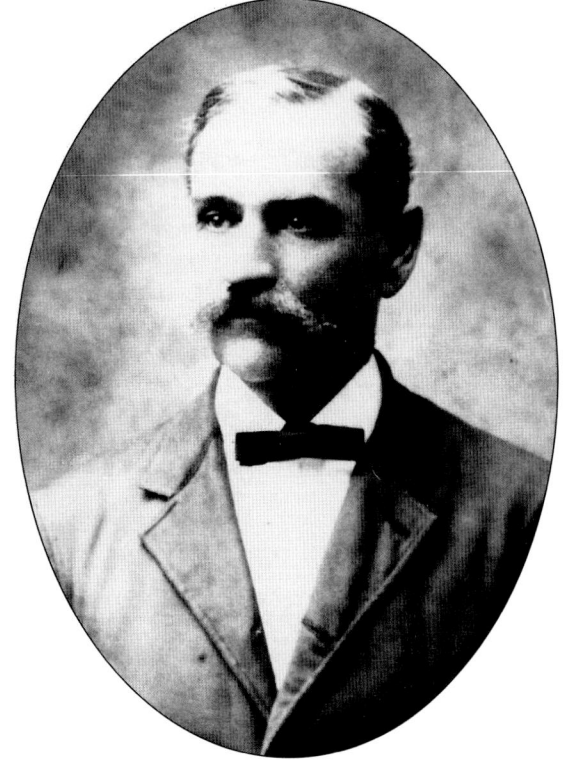

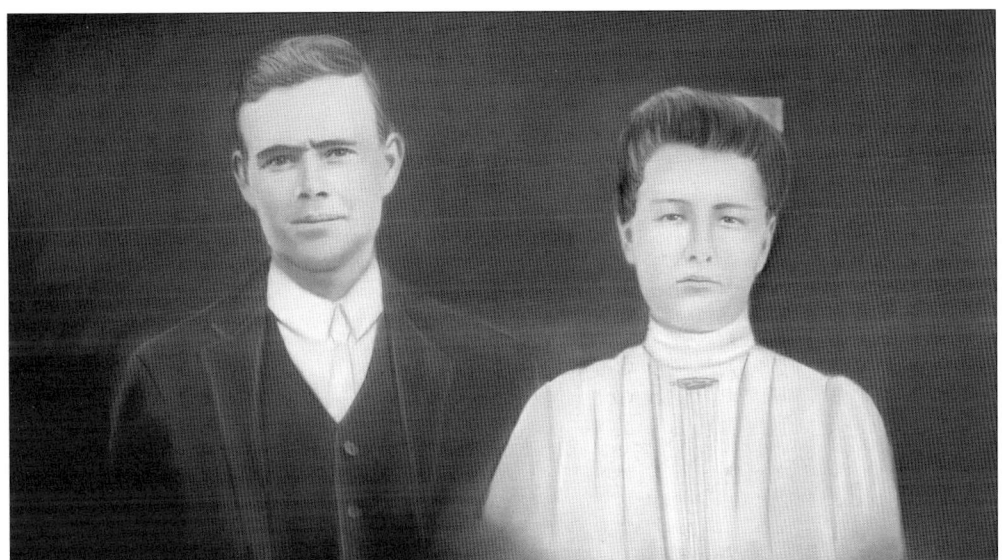

The Goodman and Rutledge families settled near the Green Pond community in the mid-to-late 1800s. Bihue Goodman (1883–1967) married Viola Rutledge (1885–1956) on December 25, 1905. By 1917, he had claimed 160 acres through the Homestead Act, and the couple had 11 children together between 1907 and 1927. He was a skilled trapper who hunted alligators, raccoons, and otters to supplement his income as a postal carrier. Presumably, he practiced both professions simultaneously, judging by the poem that was written about him: "Go Gator, Go. Go muddy your trail, 'Cause Bihue Goodman is carrying the mail." (Author's collection.)

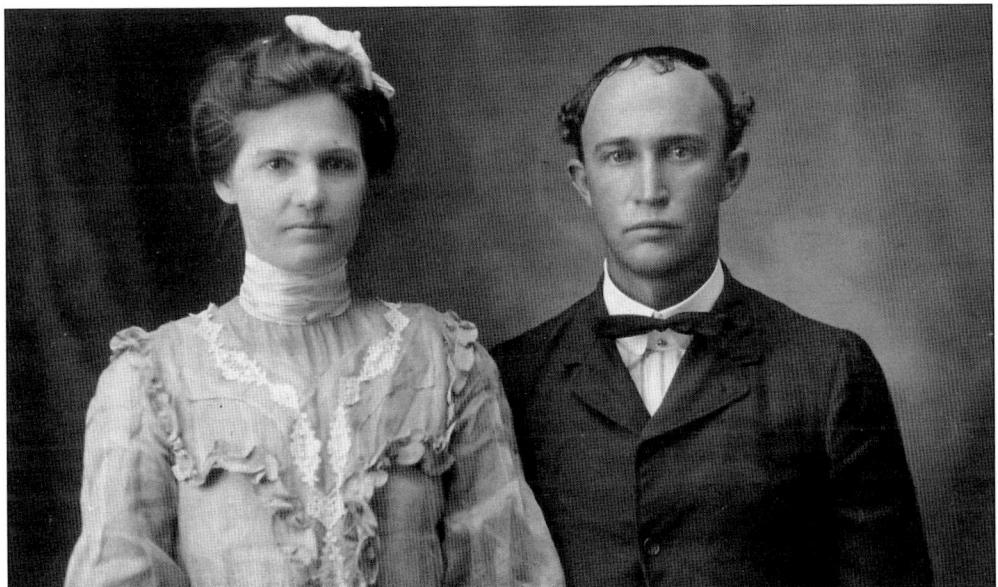

News of the marriage of Thomas Edward Meeks (1869–1955) and Pauline Williams (1875–1961) was reported in an October 6, 1899, letter to *The Lakeland Sun* with the headline "Hearts United." The letter notes that "man without aid of the womanly wife is but half a unit, the poorer half at that." The bride was one of the daughters of A.T. and Pencheeta Williams, early residents of the Green Pond area, where the couple settled to raise two sons, Alton Meeks and Herbert Meeks. (Courtesy of Sharon Kenyon Meeks.)

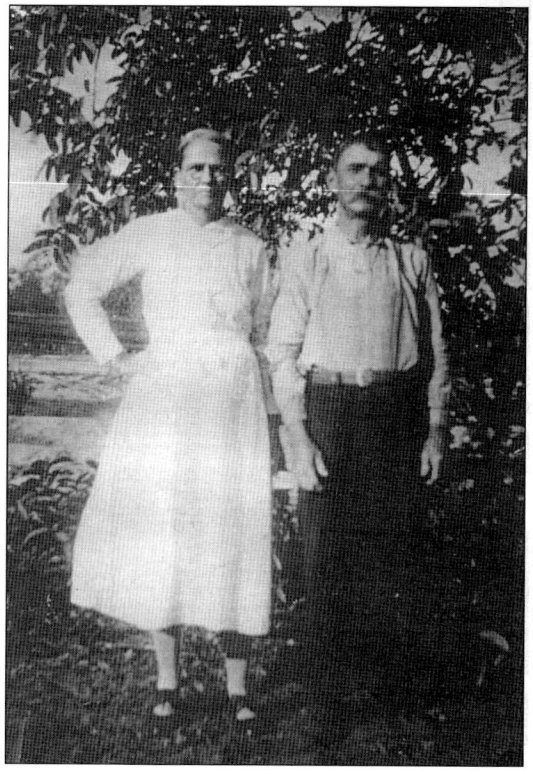

The Judy and Combee families of Green Pond were early settlers of the area. John Irvan Judy (1868–1973) married Martha Jane "Jennie" Combee in 1898. Pictured above in 1915 from left to right are Martha Judy (Tyre), John Irvan Judy, Martha Jane "Jennie," Lewis, Vinnie, Betsy Combee, and Washington "Wash." The Judys had four more children after the date of this photograph: Lois, Oscar, Albert, and Morgan. At left is Matilda Judy (1876–1965), sister to John Irvan Judy, and her husband, Noah Combee (1872–1942), brother to Martha Jane Combee Judy. (Both, courtesy of Lannis Combee Wilson.)

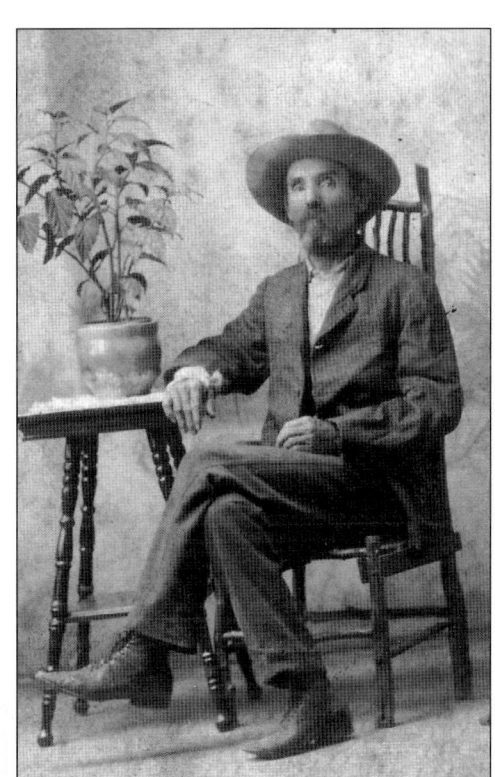

Henry Goodman (1851–1937) and his wife, Mary Ann Harvey Goodman (1857–1933), arrived in Green Pond around 1897 from the Loughman area of Polk County. The couple had 12 children between 1875 and 1899, most of whom also settled in Green Pond. (Both, author's collection.)

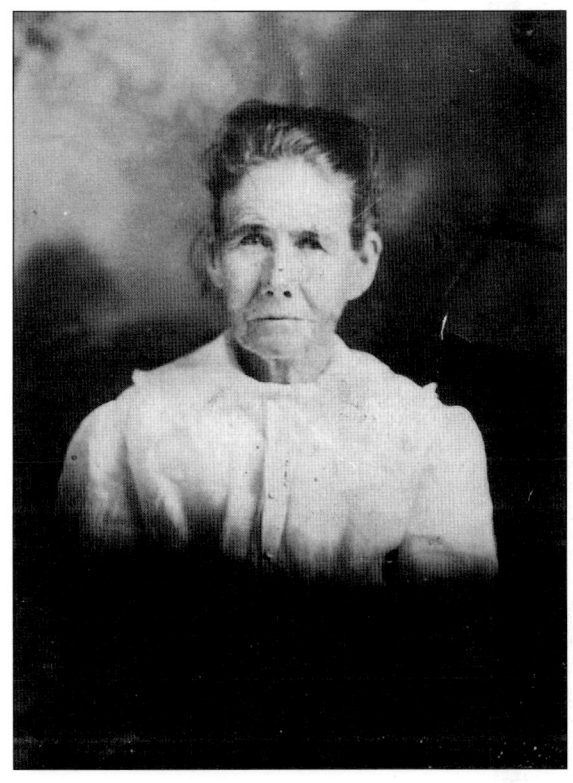

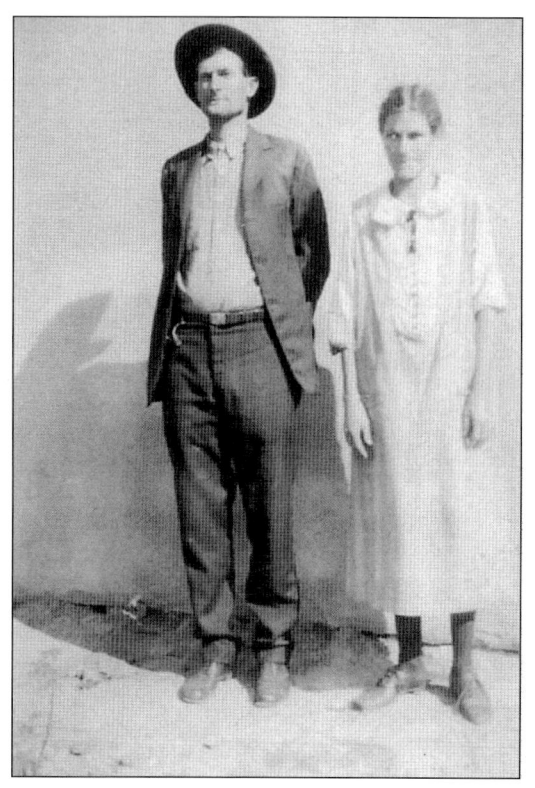

Siblings Brince Roberts (1885–1934) and Eliza Roberts (1896–1993) were two of the 15 children born to William Henry Roberts (1859–1943) and Mary Jane Hancock Roberts (1862–1930) between 1881 and 1903. The Roberts family were Green Pond pioneers. (Courtesy of Sharon Kenyon Meeks.)

Stephen Hancock (1824–1910) married Jane Emeline Townsend in 1846. He enlisted in the Florida Militia during the Seminole Wars and collected cattle in the Civil War as a private in a Cow Cavalry unit. The Hancocks arrived in Green Pond around 1890. Both are interred at Green Pond Cemetery. (Courtesy of Sharon Kenyon Meeks.)

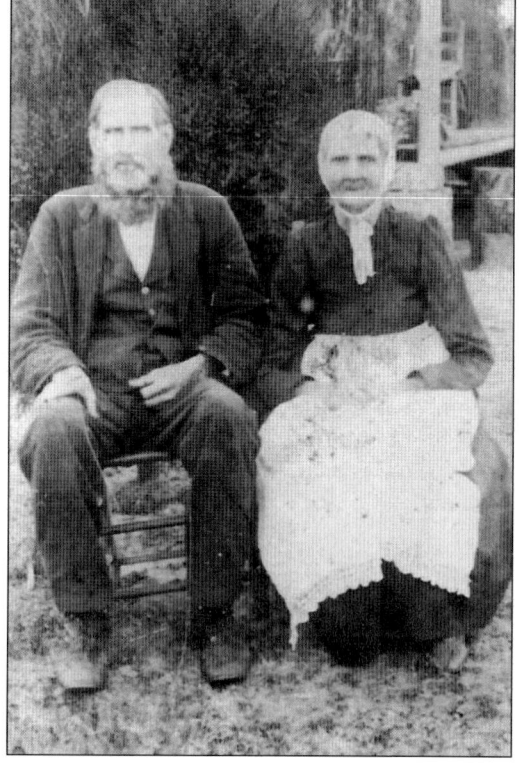

Pictured around 1914 are George Benjamin Chestnut (1883–1976), his wife, Ruby Alice Brown Chestnut (1885–1983), and three of their four children—Dallas, Carl, and Alta Mae. Alta Mae died of pneumonia just after her second birthday on July 4, 1914. (Courtesy of Glenn and Patsy Flora Bridges.)

Multiple generations of families often had gatherings on the front porches of their homes in the days before television and other distractions existed, like the James S. Lanier family pictured here around 1900. From left to right are Miriam Turner Lanier, J.S. Lanier, Vivian Elliott, Ida Isabel Lanier Elliott, Miriam Elliott, Dudley Dalton Elliott, and James Dalton Elliott. (Courtesy of Kathleen Area Historical Society.)

Thomas Winfield Judy (1886–1982) and his wife, Mae O'Steen Judy (1890–1938), pictured at left, were early Green Pond settlers from whom many present-day residents claim ancestry. John Alexander O'Steen was Mae Judy's father, and though he carries what appears to be a doctor's black bag below, there is no evidence to suggest that he was a physician. (Both, courtesy of Lannis Combee Wilson.)

The Bryant siblings illustrate both the large number of children born in families and the multiple points of connections that existed between early families of the area. The siblings pictured above were the children of Joseph L. Bryant Sr. and Caroline Handcock, pictured below. Four of the Bryant sisters married three Costine brothers. From left to right are Joseph L. Bryant Jr. (1869–1933), Florence Bryant Costine (1871–1940), Miriam Bryant Anderson (1875–1943), Mary Ann Bryant Costine (1867–1942), Lucretia Bryant Costine (1864–1924), and Arizona Bryant Brown (1862–1950). Not pictured are Carline Amanda Bryant Costine (1856–1885), Alice Eugenia Bryant Milton (1859–1884), Martha Bryant Reynolds (1873–1944), Thomas D. Bryant (1878–1932), Rufus H. Bryant (1880–1948), and W. Bethel Bryant (1882–1943). (Both, courtesy of Robbie Woodham Miller.)

Socrum resident John C.F. Witter (1858–1953), standing on the top step, was appointed postmaster of Socrum in 1914. His son and grandson followed in his footsteps as Postal Service employees. The post office was part of the Cash Grocery Company, located on the south side of West Socrum Loop Road, near present-day Socrum Elementary School. (Courtesy of Ruth Anne Witter Maloy.)

Joseph T. Mallory and Lenora Allie Hancock were married in 1897 and settled in the Kathleen/Socrum area. In an October 1914 article in the *Lakeland News*, it was noted that Mallory planned to move to Lakeland "if he can find suitable employment or a business opening." The editor of the paper endorsed Mallory as "a devout Christian," active in the Socrum church. He notes that Mallory was the assistant postmaster at Kathleen and the manager of Socrum Supply Company until shortly before it burned. (Courtesy of Phyllis Mallory Kendrick Hammond.)

Socrum residents John Everett Bryant (1875–1925) and Minnie Shuman Bryant (1876–1971) are pictured below around 1900, three years after their marriage. J. Everett Bryant served as a Polk County commissioner in 1911–1912 and then in the Florida House of Representatives. He died at 50, while his widow lived to the age of 95. Both are interred at Socrum Cemetery. (Right, courtesy of State Archives of Florida; below, courtesy of Phyllis Mallory Kendrick Hammond.)

41

William Dayton Harp and Ollie Bryant-Harp married in Polk County in 1891 and had two children, Wilburn Dayton "Bud" Harp (1903–1952) and Selma Harp-Mize (1900–1988). In addition to tending his citrus grove, Harp provided an early "taxi service" when he built a wooden, horse-drawn jitney bus with a covered top and long rows of benches on either side for seats. He transported passengers from Socrum to Lakeland, along Kathleen Road through Kathleen, Galloway, and Griffin. (Courtesy of Patrick Lombardi.)

Doctor Hankins "D.H." Brown (1860–1924) is shown with his wife, Arizona Bryant Brown (1862–1950), in front of the family home with four of the couple's sons and a crate of produce, possibly strawberries. Note what appears to be a smokehouse at the back right. Brown was not a physician; his first name was, in fact, Doctor. For a time, around 1913, he was under contract with McConnon & Company of Winona, Minnesota, selling medicines, flavoring extracts, toilet articles, and baking powder "from wagons direct to consumers." (Courtesy of John L. Hickman.)

This family photograph was taken at the Tom and Allie Hancock Mallory home in Socrum around 1926. Those pictured include members of the Mallory, Hancock, and Poppell families and illustrate the multiple points of connection between early families. (Courtesy of Phyllis Mallory Kendrick Hammond.)

Downtown Kathleen, along Railroad Avenue, is pictured here around 1910. Note the free-range pig at right. (Courtesy of Harvey Lanier.)

World War I, from 1914 to 1918, was the world's first global conflict and affected many area residents in a direct, personal way. Pictured at left is C.M. Witter Sr. (1896–1972) from Socrum, and below is Ranzy Rutledge (1895–1927) from Green Pond. Rutledge was awarded the Purple Heart. Though not recognized at the time as a treatable disorder, post-traumatic stress may have contributed to his behavior. Described by relatives as "not the same person" after the war, he was arrested for his wife's murder in 1927 and died in jail of arsenic poisoning. (Left, courtesy of Ruth Ann Witter Maloy; below, author's collection.)

Isaac Smith Coon Sr. owned and operated a fruit and vegetable exchange on Central Avenue in Kathleen in the early 1900s. In 1910, he married Annie Hancock. Two of their children, Tayzetta Coon and I.S. Coon Jr. (known as Caleb), are pictured below around 1918. (Both, courtesy of Kathleen Area Historical Society.)

Around 1922, siblings Rosemary Cox (Bridges), Lucy Cox (Anderson), and Carl Cox pose with their hobbies and pastimes: a doll, flowers, and a cat. In addition to playtime, children were expected to feed and otherwise take care of family farm animals. Grady Witter and his younger brother, Cornelius McCaskill Witter Jr. (1927–2014), are shown at left feeding the yard chickens around 1929. Free-range chickens, turkeys, and guinea fowl were a common sight in the yards of area residents. The loud, noisy guineas were valued for their watchdog abilities, sounding a screeching alarm when someone entered the yard. (Above, courtesy of Patsy Flora Bridges; left, courtesy of Ruth Ann Witter Maloy.)

A gristmill was in operation on Ross Creek Road in the late 1800s and early 1900s, powered by the water of nearby Ross Creek. The mill served area residents for miles around, converting corn to cornmeal, a staple of the local diet. Posing in front of the mill around 1920, are, from left to right, Charlie Ross, Ebo Tilton, unidentified, and Clark Gavin. (Courtesy of L. Rabun Battle.)

In addition to farming and cattle raising, many early 1900s residents depended on carpentry for their livelihoods. Shown here with the tools of the trade in hand are, from left to right, Chester Poppell (1883–1964), Fred Brown, and Leonard Costine (1882–1969). (Courtesy of Robbie Woodham Miller.)

Sisters Hazel Wheeler (Reynolds) (1877–1946) and Elma Wheeler were lifelong residents of the Griffin/Galloway area. They were the daughters of Sarah Robertson Wheeler (1877–1946) and George W. Wheeler (1869–1930), for whom George Wheeler Road is named. (Courtesy of Carlton Phelps.)

Connie Galloway (1892–1944) is pictured with an unidentified friend and man's best friend. The manner of dress, including Galloway's sleeve garters on each arm, is at odds with the unknown setting in front of a tent. Galloway married Hazel Prine in 1919. (Courtesy of Geraldine Galloway Randle.)

Two

HOME SWEET HOME

Pioneer homes ranged from the simple to the sublime to the unique. Pictured here are Israel and Mary Ann Vickers Sherouse and three of their 10 children—Etta, Nettie, and Paul—around 1912 in their cracker cabin on present-day Sherrouse Road in Socrum. The kitchen structure attached to the right rear of the home was a common and practical design, separating the heat generated in the kitchen from the remainder of the house. The yard is devoid of any grass, another common practice of the era. (Author's collection.)

The home of C.C. and Florence Neel Hancock was located on S.B. Merrion Road in Socrum and still stands today, though moved from its original location. The Hancock's son Oreon Hancock (1903–1977) is pictured with his dog around 1915. (Courtesy of Susan Hancock Lanier.)

Another Hancock family two-story house, pictured here around 1918, featured an unusual design. The house was hexagonal, and the only staircase that led to the second floor was located on the front porch, visible on the left side of the porch in this photograph. From left to right are Simeon Hancock (1877–1960), Tayzetta Coon (1914–1979), Flossie Hancock, and John A. Hancock (1853–1930). The house was destroyed by fire in the 1980s. (Courtesy of Angela Fenton Slappey.)

The Sutton family gathers in front of their home, located between Galloway and Winston at 3230 West Bella Vista Street, in 1908. Charles Sutton and Rachel Keen were married in 1889 and are pictured here with their children. From left to right are Charles Sutton and Rachel Keen Sutton, Bascom Sutton, John Sutton, Pearl Sutton Rushing, Monroe Sutton, Eugenia Sutton Coleman, Leola Sutton Walker, and Rhoda Sutton Harris. By 1910, Bascom Sutton was teaching second grade at Winston School and later served as a minister at Kathleen Baptist Church. (Courtesy of State Archives of Florida.)

This house was once home to Socrum's Methodist Episcopal Church, South congregation. Around 1910, the structure was relocated to the corner of Kathleen and S.B. Merrion Roads and renovated into a home for J. Edd, known as "Whistling Ed," (1884–1962) and Jennie Bowen Bryant (1888–1974). The couple is pictured around 1918 with three of their four children (from left to right) Loyce, Wayne, and Bernice. Their son Kirby was born in 1920. The Bryants raised vegetables and sold them at the curb market in downtown Lakeland for many years. Jennie Bryant taught at the Socrum School prior to their marriage. (Courtesy of Ginny Bryant Hester.)

The home pictured here around 1916 was owned by Jesse Harris (1875–1942) and his wife, Miriam Bryant Harris (1876–1931), and was located on West Socrum Loop Road. The Harrises sold the home and 30 acres, used for strawberry farming, to John Council Gandy prior to 1920 for $2,500. Pictured in the foreground from left to right are Marvin Grady Harris, Ruth Clarissa Harris, and Pearl Harris. On the porch is Miriam Bryant Harris. A fourth child, Leslie Harris, is not pictured. (Courtesy of Ruth Ann Witter Maloy.)

The Ed Bridges home was built around 1910 and was located on Banana Road in the Providence/Socrum area. The home still stands today. Ed Bridges operated a sawmill on the property, and there was also a smokehouse and a water tower. Pictured here around 1917 are the Bridges children (from left to right) Jesse and John, with Emma Bridges holding baby Hollis. (Courtesy of Glenn and Patsy Flora Bridges.)

The home of S.J. (1880–1963) and Helen Grist McClure (1888–1980) was built around 1922 to replace the log home seen here at right. The home still stands today on Kathleen Road, just north of Block Prine Road in Kathleen. Both McClures served in World War I, S.J. McClure as an Army lieutenant and his wife as an Army nurse. Helen McClure is pictured on the porch holding her son Bruce (1921–1966). (Courtesy of Helen Lingard.)

The George Benjamin Chestnut family home was located off Knights Station Road in the Winston community and included numerous outbuildings to support the family's livelihood, which included the growing of vegetables and citrus and also cattle raising. Note what appear to be wagons under the structure on the right. (Courtesy of Patrick Lombardi.)

The Frank Gavin (1868–1944) home was located in Kathleen, immediately adjacent to the railroad tracks near the Kathleen Depot. The home featured a wraparound porch, which was a practical design in the days before air conditioning. Gavin and his wife, Rosa Emerson Gavin (1877–1967), raised six children in the home. (Courtesy of L. Rabun Battle.)

Long before Heritage Park in Socrum was established as the headquarters for the Kathleen Area Historical Society, the site was the homestead of George (1853–1931) and Susan Lanier Bryant (1862–1918) and their three children, Arthur (1881–1948), Lenora (1883–1964), and Gettis (1885–1962). Lenora and Gettis (pictured) continued to live in the home until their deaths in the 1960s. The home never had electricity or plumbing. None of the three siblings ever married. (Courtesy of Susan Catt Beshears.)

Fencing around homes was common and served primarily to keep free-range cattle out of yards. The Morgan Prine family is shown above with matriarch Catherine Rogers Prine seated. Below is the home of Thomas Irving Stalvey (1881–1972) and his wife, Goldie Prine Stalvey (1889–1964), along with the family dogs. The Stalveys were the parents of one of the founders of the Kathleen Area Historical Society, Doris Stalvey Glisson. (Above, courtesy of Kathleen Area Historical Society; below, courtesy of Becky Hardaker Elliott.)

The Tucker home, pictured here in the early 1900s, is still standing in the Kathleen community, though in deteriorating condition. Martha Hancock Tucker (1858–1947) is on the left. The woman on the right is unidentified. (Courtesy of Phyllis Mallory Kendrick Hammond.)

The J.T. "Tom" Mallory family poses in front of their farmhouse around 1904. The home was located in Socrum. From left to right are Mallory, holding son Ralph; Mallory's wife, Allie Hancock; unidentified; and Colonel Foster. (Courtesy of Phyllis Mallory Kendrick Hammond.)

Two of the finer homes in the Providence/Socrum area around 1918 belonged to the James W. Lanier family (above) and the James Jasper Robertson family (below). The two-story Lanier home in Providence, above, is pictured with, from left to right, James W. Lanier; his wife, Sarah Sherouse Lanier; Mary Lanier Roberts holding Verna Roberts; John Roberts; and Susan Lanier. On the second-floor porch are Hettie Moore Lanier and her husband, Dallas Lanier. The Robertson home, below, is located on Raulerson Road in Socrum and, though still standing, is in process of demolition. Standing in front of the home from left to right are Marsaline Wilder Robertson (1856–1932) and her daughters, Annie Ellen Robertson Stanley (1898–1964) and Lydia Robertson Totty (1886–1943). (Above, courtesy of Harvey Lanier; below, courtesy of A. Glenn Brown.)

The Carpenter's Home features a Mediterranean design and is located in the Gibsonia area. This facility for retired carpenters was built by the International Brotherhood of Carpenters and Joiners and dedicated in October 1928. The home was closed in 1976, and the property was then purchased by the First Assembly of God Church in 1981. The Carpenter's Home building served for several years as a church-affiliated school but is currently vacant and in disrepair, though a recent buyer plans to restore the building. Shown above is one of two entrance gates, and below is the facility while under construction. (Both, courtesy of City of Lakeland Public Library, Special Collections.)

Three
OLD-TIME RELIGION

Churches and old-time religion were the spiritual and social foundation of Kathleen area communities. Crude structures, like this brush arbor, were often among the first structures built as settlers arrived. Circuit riders or saddlebag preachers filled important roles in early churches, traveling on horseback from one sparsely populated location to another along a loosely organized circuit of churches. They offered services known as "camp meetings" to settlers. (Courtesy of Thomas E. Guinn.)

Rev. J.M. Hayman (1822–1922), a circuit rider, enjoyed a 50-year ministry in multiple central Florida counties, including the 1850s-era congregants at the Socrum site of what would become Bethel Baptist Church in 1863. Historian Hampton Dunn noted that Hayman's journal revealed that during a two-year period in the early 1850s, he preached 186 sermons, traveled 3,094 miles, baptized 42 people, and received about $235 in pay. He also led the effort in organizing the South Florida Baptist Association at Bethel in 1867 and served as clerk of circuit court in newly formed Polk County from 1863 to 1866. He is interred at Oak Hill Cemetery in Bartow. (Courtesy of Bethel Baptist Church.)

Bethel Baptist Church in Socrum is the oldest church in the Kathleen area, formally established in 1863 with 19 members. However, services were first held in Socrum at Indian Pond, adjacent to the church, in the 1850s. In its 152-year history, the church has sponsored several other local churches, including Gibsonia Baptist Church and Mount Tabor Baptist Church. The building shown here around 1905 is the second sanctuary, with Rev. E.L. Todd holding the open bible in the right center foreground. (Courtesy of Bethel Baptist Church.)

A Women's Missionary Union was first organized in 1888 at Bethel Baptist Church to support foreign missionary work. Two members of Bethel, Cora Hancock Blair (1890–1971) and her husband, Martin Blair, served as field missionaries in Argentina, beginning in 1919. At the time of her death in 1971, Mrs. Blair was serving as missionary emeritus to Argentina. (Courtesy of Phyllis Mallory Kendrick Hammond.)

Similar to the days of circuit riders, it was common practice for pastors to serve multiple churches at various intervals over a period of years. Rev. C.C. Hancock (1877–1958) was ordained in 1914 by the Kathleen Baptist Church, and he and his wife, Florence Neel Hancock (1882–1974), served at Bethel, Kathleen Baptist, and Green Pond. The couple is pictured here around 1902. Both are interred in a mausoleum at Socrum Cemetery. (Courtesy of Susan Hancock Lanier.)

61

To the early residents of the Kathleen area communities, churchgoing for spiritual education was equally as important as school attendance for book learning, if not more so. In 1926, the W.T. and Donie Harrison family was recognized as one of the largest and most active families at Socrum's Bethel Baptist Church. (Courtesy of Bethel Baptist Church.)

Many early local ministers did not have formal theological training but were self-taught students of the Bible and "ordained" by a church congregation. Rev. Samuel Craft Sloan (1875–1933), pictured with his wife, Flossie (right), was an early exception in that he attended Stetson University and was a seminary graduate. He served as pastor at Bethel Baptist Church on three occasions: 1901–1904, 1905–1908, and 1910–1923. Rev. Warren Entzminger (below) served as pastor at Bethel Baptist Church in 1908–1910 and 1923–1927. He was a graduate of Furman University. (Both, courtesy of Bethel Baptist Church.)

Pleasant Grove Primitive Baptist Church in Socrum doubled as a school. The church came into existence after a division between the missionary and the anti-missionary elements of Bethel Baptist Church in 1890. The building was later sold to J.A. Dunn and used as a home. Pictured are teacher C.A. Parker and students in 1908. (Courtesy of Bethel Baptist Church.)

Indian Pond at Bethel Baptist Church in Socrum was the site of many baptisms, like the one pictured above in 1925. A formal baptistery was added in 1951 to the adjacent 1928 church building, and baptisms in Indian Pond ceased. Ironically, an oft-repeated tale is that the community's name of Socrum has its origins in the baptismal pond, which was used by early settlers to "soak rum" to keep the spirits cool. Indian Pond is still a source of reverence and pride today. (Above, courtesy of Phyllis Mallory Kendrick Hammond; below, author's collection.)

According to church records, early meetings of Kathleen Baptist Church were first held in 1895 in a log building, north of Ross Creek near present-day Kathleen Middle School. Baptisms were held at the millpond on Ross Creek Road. The cabin was struck by lightning in the summer of 1914 and burned down. This sketch depicts the replacement church building, which was constructed around 1914 on Second Street Northwest in Kathleen. Rev. Albert A Keith (1843–1927), below, served as the first pastor at Kathleen Baptist Church from 1895 until 1897. (Left, courtesy of Kathleen Baptist Church; below, courtesy of Vance Pollock.)

Joseph W. Tucker (1855–1942) first served as a deacon at Kathleen Baptist Church in 1900, before becoming the congregation's pastor from 1916 to 1919. He married Martha Hancock (1858–1947), pictured below, in 1878. Tucker was the first person in the area to take formal vacations, always to North Carolina, and he was invited to Kathleen School every year to talk about his trips. To students of the era, North Carolina seemed like a place halfway around the world. (Both, courtesy of Phyllis Mallory Kendrick Hammond.)

Schools and churches often shared the same building or the same property in the 1850–1900 era. In the foreground is Little Flock Primitive Baptist Church in the Rockledge (now known as Rockridge) area near Green Pond. In the background is the Rockledge School. Pastors also served double duty, frequently teaching classes in the schools. (Courtesy of Kathy Sherrouse Watkins.)

Mitchell Hughes (1881–1952) and Florence Azalene "Lena" Rutledge Hughes (1883–1970), with daughter Cynthia Hughes Roberts (1903–1985), were early Green Pond residents. Hughes was a "hard shell" (Primitive Baptist) preacher who conducted services at Little Flock Primitive Baptist Church, located on Rockridge Road in the community of Green Pond. (Author's collection.)

The Kathleen United Methodist Church at Polk Avenue and Second Street in Kathleen was constituted on June 20, 1900, from members of Socrum's Episcopal Methodist Church, South congregation. The congregation first met in the nearby two-room Kathleen School building. The building shown here in 1905 was originally a home that was purchased for $200. After renovation, the building served as the church's home until 1968, when a new brick sanctuary was built. One item that was retained from the 1905 building was the church bell, which was originally ordered from Sears Roebuck in Chicago for $23 plus $6 for freight. (Courtesy of Kathleen United Methodist Church.)

Griffin Baptist Church was founded in 1904 as a mission of Mount Tabor Baptist Church. The first services were held in a brush arbor, and Rev. R.T. Caddin was the first pastor. The original wooden sanctuary, built in 1905, was sold in 1959, and a new block building was erected on-site and remains today. (Author's collection.)

Mount Tabor Baptist Church was established on September 11, 1887, sponsored by Bethel Baptist Church in Socrum. Services were first held in a brush arbor for approximately two years until 1889, when a small frame building was constructed. That original building burned down, and this white, rectangular frame building was erected around 1900. The first pastor was J.L. Simmons, who served from 1887 to 1903. (Courtesy of Mount Tabor Baptist Church.)

In 1969, the present-day sanctuary was constructed, across the road from a church built around 1900. The portico of the 1900 building remains on-site today, on the grounds of the cemetery. Mount Tabor Church is located in the Galloway area at 3504 Mount Tabor Road. (Courtesy of Mount Tabor Baptist Church.)

Before the New Home Baptist Church sanctuary was built, Rev. Steve McClelland held the first service at the Winston School in October 1913. The church was organized on August 25, 1912, with a membership of 27 people as a mission from Mount Tabor Baptist Church. Land for this building was donated by L.T. Keen and J.L. Smith. (Courtesy of New Home Baptist Church.)

The Chestnut family, pictured around 1911, were active in New Home Baptist Church. Patriarch William Hiram Chestnut (1850–1939) arrived in the Griffin/Galloway/Winston area from Melrose, Florida, in 1880 and married Minnie Etta Hillyer (1866–1944) in 1882. He was a charter member of the church and is credited with suggesting the name of "New Home." From left to right are Alice Chestnut Bates, Willie Ramon, Albert James Sr., George Benjamin, Minnie Ella Chestnut Colemon, Elizabeth Mae Chestnut Perkins, Margaret Scott Chestnut Harp, William Hiram (patriarch), Sidney Hanford, Minnie Etta (matriarch), and Paul Edgar. (Courtesy of Patrick Lombardi.)

The Green Pond Baptist Church was organized on September 21, 1894. Witnesses to the organization of the church are recognizable names from the early history of the larger Kathleen area: E.G. Wilder, deacon of Bethel Baptist Church; J.W. Costine, clerk of Antioch Church; and D.C. Combee, deacon of Gapway Church. The structure shown here was completed around 1900, though the wing additions, shown attached to the left and right sides of the main structure, were added in the early 1950s. The original church building was demolished in the summer of 1972 and replaced by present-day Green Pond Baptist Church. (Courtesy of Sharon Kenyon Meeks.)

This marker was erected on the site of Green Pond Baptist Church and Cemetery in 2014 by the late Thomas L. Meeks, who descended from pioneer settlers. (Author's collection.)

Four

BOOK LEARNIN', BOBS, AND BARE FEET

Socrum School was one of two schools established by the Hillsborough County Commission in 1854 to serve the area's growing population. Polk County would not be formed until 1861. This class from 1907 included teachers Jake O'Hara and Mae Lewis, standing on the top steps. By 1887, the Board of Public Instruction was funding 69 community-based schools scattered across Polk County, though schools were funded for only five months per year. (Courtesy of Kathleen Area Historical Society.)

Class sizes were quite small by today's standards and incorporated first through eighth grades only. This first grade class at Socrum School is from around 1910 and includes Wilburn "Bud" Harp (1), Jessie Bowen (3), Fay Fletcher (6), and Leslie Harrell (8). The other students are unidentified. The school was located across the road from Bethel Baptist Church. (Courtesy of State Archives of Florida.)

S.L. Collins (1884–1944), left, was a longtime teacher and principal for Kathleen area schools, as was his wife, Berchie Stroud Collins (1890–1978), third from left, whom he married in 1911. Also pictured are Frankie Raulerson and Hicks Fletcher. (Author's collection.)

Polk Board of Public Instruction minutes and a teacher's daily register from the 1880s indicate that teachers were paid from $40 to $50 per month at that time. By 1910, salaries had increased to as much as $70 per month. Teachers and students at Socrum School in 1909 included, from left to right, student Gertie Bowen, teacher Etta Cowan, principal S.L. Collins, and students Jennie Bowen and Jattie Robertson. (Courtesy of State Archives of Florida.)

Bare feet and overalls were the unofficial school uniform of the day in the 1920s at Socrum School and other area schools, reflecting the rural nature and economic hardships of the era. Long, curly hair or elaborate updos were no longer in vogue for girls' hairstyles. Instead, schoolgirls sported the "bob," a short, blunt cut with bangs. Two future Kathleen area teachers are pictured here around 1927. These are Rosemary Cox Bridges (sixth row, fourth from left) and Margaret Chestnut Harp, over Mrs. Bridges's right shoulder. (Courtesy of Patrick Lombardi.)

Early school days in the Kathleen area lasted from 8:00 a.m. until 4:30 p.m. and included the study of reading, spelling, history, and geography. The schools were heated by four-legged cast iron stoves, fueled by the resin of pine lightard knots in the winter. Open windows provided "air-conditioning" in the summer months, as shown in this photograph of a Socrum School class around 1924. (Courtesy of Kathleen Area Historical Society.)

Socrum School operated until May 6, 1936, when the two-room frame school was destroyed by a fire of unknown origin. The structure and its contents were valued at $3,000, with only a few desks and the piano salvaged. At the time, the school reported 69 students. Teacher J.C. Byrd (1906–1992) is shown here with students in 1930, his first year of teaching. The community of Socrum was without a namesake school until 1991, when Socrum Elementary was built approximately one quarter mile from the original Socrum School location. (Courtesy of Kathleen Area Historical Society.)

Selma Harp Mize (1900–1988) was a longtime educator in Kathleen area schools, serving as a teacher and a principal at Socrum, Gibsonia, and Kathleen Schools. She began teaching in 1928 and is pictured here around 1930 with her husband, Isaac Aquilla Mize, and their daughter Floy Mize Sawyer. (Courtesy of Phyllis Mallory Kendrick Hammond.)

Margaret Chestnut Harp (1900–1951) was a teacher with connections to multiple communities and pioneer families of the Kathleen area. She was born in Galloway in 1900 and graduated from Kathleen School, receiving her teaching certificate in 1920. She then began a 24-year teaching career at Griffin School before becoming principal at Winston School. She died of injuries from an automobile accident in 1951 and is interred at Socrum Cemetery. (Courtesy of Patrick Lombardi.)

The Griffin Grammar School is located at 3315 Kathleen Road and was originally established in 1900. The original school building burned down, and the main building that now houses the Library Media Center and Office for present-day Griffin Elementary was rebuilt in 1931. Pictured here is a class from the 1920s, with Margaret Chestnut Harp as teacher. (Courtesy of Patrick Lombardi.)

The Cox surname became synonymous with education in the Kathleen area and throughout Polk County. Pictured is the patriarch James Abner Cox (1837–1923), who was educated in mathematics at the University of Mississippi. After serving the Confederacy in the Civil War, he moved his family to Polk County and initially settled in the Kathleen community around 1890. There, Professor Cox and his daughter Helia established a private school on Ross Creek, which eventually became Kathleen School. In 1928, a grammar school in Lakeland was named after John F. Cox, a son of Professor Cox. A granddaughter, Rosemary Cox Bridges, was a longtime educator at Kathleen area schools. (Courtesy of Hampton Dunn.)

Carl Mallory (1875–1905) taught at the Avenue Pond School, just west of Hancock Road in Socrum, for a short time (1900–1902). He then became principal at the Knights School just across the Polk/Hillsborough County line at the intersection of Knights Griffin Road and Highway 39. In 1905, Mallory was killed in a tree trimming accident. Pictured with Mallory are his wife, Pauline Wilder Mallory (later Bradford), holding daughter Lucille, and Pauline Mallory's mother, Martha Jane Wilder. (Courtesy of Phyllis Mallory Kendrick Hammond.)

Green Pond School was in operation in early 1886, as evidenced by minutes of the Board of Public Instruction from that year, wherein $180 was granted for teacher salaries and operations. The first school at Green Pond was located at Green Pond Baptist Church, but a separate school building was eventually built. Many of the students pictured here around 1907 are from the same family, children of William Henry Roberts (1859–1943) and his wife, Mary Jane Hancock Roberts (1862–1930). (Courtesy of Sharon Kenyon Meeks.)

In the early 1900s, community residents elected local school trustees for individual schools, and these trustees hired the teachers. The trustees reported to the Polk County Board of Public Instruction. It was not until the mid-1930s that a college education was required of teachers. Up until that time, a teaching certificate, issued by the State Department of Education after a three-day examination, was all that was required to teach. Pauline Lovell Raines (1899–1983), a teacher at Green Pond School in the early 1900s, was one of many who taught under the teaching certificate practice. (Courtesy of Sharon Kenyon Meeks.)

After reportedly being located at or near Green Pond Baptist Church in its earliest years, Green Pond School moved to the north side of Poyner Road at its intersection with present-day State Road 33 in Polk City. This c. 1926 photograph includes children from four early Green Pond area families: the Combees, Judys, Meeks, and Roberts. From left to right are (first row) Phelson Blair, ? Tidwell, Thelma Judy, Edna Wester, Edna Roberts, Alma Kirkland, Myrtle Judy, Lesley Judy, and Ellis Judy; (second row) Alton Roberts, Quinton Roberts, Reba Lou Tidwell, Ethel Roberts, Jewell Tidwell, A.T. Wiggins, and Robert Judy; (third row) Cleveland Kirkland, Addie Combee, Herbert Meeks, Jeanette Rivers (teacher), Charlie Black, and Agnes Wester. (Courtesy of Sharon Kenyon Meeks.)

Lela Brown (1898–1936) began teaching shortly after graduating from Lakeland High School. After teaching at Carver School near Auburndale, Lake Parker School in Lakeland, and at Gibsonia School, she died during childbirth in 1936. The original Gibson School was established in 1895 on the south side of Lake Gibson and later relocated to the northeast corner of present-day Daughtery Road and Highway 98 North. The former site of Gibsonia School is now the location of a CVS drugstore. (Courtesy of A. Glenn Brown.)

In response to a petition by Alexander Bryant for a new school in Providence, Polk County Board of Public Instruction minutes from July 1887 record that "they can make a school of 17 pupils and that they are in an isolated position. Therefore, the petition is granted with said school to be known as the Providence School." The school was located at the northwest corner of Wilder and Mathews Roads. Shown above is a Providence School class from 1927, and below, another from around 1924. (Above, courtesy of Patsy Flora Bridges; below, courtesy of Mae Wilder Wiggins.)

Providence School operated from 1887 until 1937, when it was incorporated as part of Kathleen School. A portion of the school building was moved to the grounds of present-day Kathleen Middle School (then known as Kathleen High School) to serve as the home economics classroom in 1937. (Courtesy of Leslie Costine.)

Three Shumate sisters are shown standing on Main Street in Kathleen around 1916. From left to right are Mary Brown of Socrum, Sarah Shumate of Bartow, and Rebecca Tolliver Mosely of Kathleen. Of the seven Shumate sisters, five were teachers. (Courtesy of John L. Hickman.)

Prior to 1900, a private school was operated by James Abner Cox on Ross Creek Road in Kathleen. The one-room, unsealed schoolhouse became known as Kathleen School in 1900, when a new structure was built along Central Avenue and Kathleen Road, pictured around 1911. The frame school building was sold in 1928 to the Church of God for $2,000. (Courtesy of State Archives of Florida.)

S.L. Collins is pictured with his pupils around 1925. He helped lead the effort for the new Kathleen School in 1928 to serve first through twelfth grades. (Courtesy of State Archives of Florida.)

In the mid-to-late 1920s, school construction materials were upgraded from wooden frame to redbrick. Above, teacher Berchie Stroud Collins is pictured with one of the last classes at the wood-frame Kathleen School in 1927. Below, a brand new redbrick Kathleen School was built in 1928, and Collins continued her long teaching career at this location. (Both, courtesy of Kathleen Area Historical Society.)

Until 1928, there were no high schools in the Kathleen area. Schools offered only first through eighth grades, unless families were able to provide transportation to Lakeland High School (built in 1902) and pay tuition for an out-of-district school. The lack of transportation and tuition costs proved to be insurmountable obstacles for many area families, resulting in many students with only an eighth grade education. In 1928, Kathleen's first high school was built (now Kathleen Middle School at 3627 Kathleen Pines Road), a two-story redbrick building with a basement that is still in use today. The first graduating class of Kathleen High School, consisting of six students (Rosemary Cox Bridges, Seeny Fields Risk, Nellie Harrison Gandy, W.T. Harrison Jr., Harry O. Prine, and Stephen A. Cooper), graduated in 1932. (Courtesy of State Archives of Florida.)

Thomas W. Bryant (1890–1992), first row, third from left, was born and raised in Socrum and attended school in the community until the eighth grade. His family moved to Lakeland to afford him the opportunity to obtain a high school education, and he founded the first football team of the Lakeland High School Dreadnaughts in 1907. He went on to graduate from the University of Florida with a law degree and served three consecutive terms in the Florida legislature. Bryant Stadium in Lakeland is named after him. In one of several interviews over the years, he noted, "I never wanted to sit at the head table, but I've always been interested in who was." (Courtesy of City of Lakeland Library, Special Collections.)

Though schools did not provide an abundance of extracurricular activities, Kathleen and Providence Schools both fielded baseball teams in the 1920s. The Providence team, shown below, was known as the Bears. (Above, courtesy of State Archives of Florida; below, courtesy of Mae Wilder Wiggins.)

A one-room school was in operation in the Winston area by 1894, though the school was not known as Winston School until around 1905. The first school erected on the present-day site of Winston School was lost to fire. In an effort to smoke out fleas, brought by hogs that were permitted to lie beneath the building, pine needles were set on fire underneath the building, resulting in the loss of the wooden structure. A one-room replacement structure was built around 1900, with two classrooms added in 1905. This wooden structure, shown here in 1924, was torn down around 1927 to make room for the first brick structure, which still stands today. (Courtesy of Winston Elementary School.)

After strawberry farming was established in the Kathleen area in the late 1880s, schools in the area became known as "strawberry schools." Schoolchildren were expected to help with the strawberry harvest from January through March. Winston School and Griffin School were two of six schools that followed this schedule, with school in session from late April through December. Both schools are listed in the National Register of Historic Places. The strawberry school schedule was discontinued in 1952. (Author's collection.)

The redbrick Winston School was built in 1928 at a contract price of $17,926 by Ridge Construction Company. Designed by G.D. and H.D. Mendenhall Architects of Lakeland, the building is characterized by Tuscan columns and a gabled portico entry. The seventh grade class of 1934 is shown between the columns with teacher Clyde Hall. (Courtesy of Kathleen Area Historical Society.)

The 1934 third grade class of Griffin Elementary is shown here; the teacher is Vera Hall. Both Winston and Griffin schools were built in the same era and feature similar architectural designs. (Courtesy of Kathleen Area Historical Society.)

Beginning in the 1920s, school construction design was supervised by professional architects for the first time. Arch D. Holsinger served as the Griffin School architect for the new redbrick Griffin School, which was built in 1931 by Albinson & Company for $14,121. The Griffin School was modern and up-to-date, with its own water system and electricity from the Lakeland power plant. (Courtesy of Polk County History Center.)

The second and fourth grade classes from Griffin School in 1934 are pictured with teacher Frances Chiles, who was an aunt to future US senator, Florida governor, and Lakeland native Lawton Chiles. (Courtesy of Marjorie Poston Butler.)

This Winston School class from around 1911 included students with surnames representative of many early Winston area families, such as Bates, Brown, Chestnut, Keen, and Walker. Three teachers are standing at right center: C.A. Parker with coat and bow tie, Bascom Sutton with tie, and Dixie Pillaus in the long dress. (Courtesy of Ruth Chestnut Seng.)

Formal school bus transportation was not available in the Kathleen area until the 1930s. In the late 1920s, local area resident Ed Bridges was hired by Polk County to drive the first school bus for Kathleen School students. He furnished the truck and built a boxlike structure on the back for students, similar to this bus that was used for Winston School transportation. (Courtesy of City of Lakeland Library Special Collections.)

Five

THE LAND'S BOUNTY

In the early 1900s, "exaggeration" or "tall tale" postcards were popular and served to illustrate an element of local pride regarding the size of the crops grown, as shown with these Florida strawberries. The agricultural base of the Kathleen area, consisting of farming (especially of strawberries) and cattle raising, received a significant boost with the coming of railroads in the 1880s. The railroads spurred growth throughout the Kathleen area and the state of Florida, providing a means of transportation for new residents and tourists and a way for farmers and cattle ranchers to ship their goods throughout the United States. (Courtesy of Special & Digital Collections, Tampa Library, University of South Florida.)

Many Kathleen area pioneer families arrived with small herds of cattle or rounded up free-roaming "cracker cattle" left over from Spanish occupation of the territory of La Florida. The cattle industry was the original foundation of the Kathleen area agricultural economy. One Kathleen area cattle-raising family was led by W.H. "Bill" Costine (1856–1942), shown here in a painting created by local artist Renata Pastula that was based upon a photograph taken around 1925. (Author's collection.)

Cattle drives were a common sight dating back to the 1860s and continuing until the late 1940s. Initially, cattle drives were undertaken when trade was initiated with Cuba, with thousands of cattle driven to docks in Tampa and the Fort Myers area for shipment by steamship. Specific to the communities in the Kathleen area, it was necessary to move cattle just prior to the rainy season from the flatlands of the Green Swamp east to the sandhills of Davenport and Loughman and then back after rainwaters had receded. Cattle owners pooled their resources and also hired extra hands, known as cow hunters, to accomplish the multiday drives across open range uninterrupted by fencing. (Courtesy of State Archives of Florida.)

The term "cracker" is often used to describe the mid-1850s settlers of the communities of the Kathleen area and their descendants, who had an affinity for cattle. The term originated from the settlers' use of buckskin cow whips, which were popped and cracked to control the movement of large herds of cattle on the open range. The term is also used to describe those who were and are multigenerational residents. Shown above are Joe Williams and Joseph Mizell (1882–1965) with cow whips in hand. Mizell later served as police chief for the city of Bartow, Florida. (Courtesy of Ben Richey.)

On a visit to Florida in August 1895, artist Frederic Remington created illustrations of "Cracker Cowboys" that were less than flattering. Many took offense to his use of the term "cowboy" instead of the more widely accepted and accurate "cowhunter." (Courtesy of State Archives of Florida.)

The coming of the railroads to the Kathleen area revolutionized cattle ranching, the citrus industry, and farming, since the railroads made shipping of commodities by rail possible. Since Florida did not enact the Fence Law until 1949 ("open range" was the norm), this photograph from around 1890 illustrates the challenge that progress sometimes created. "Train fear" resulted in some cattle owners shooting at locomotives because their cattle were sometimes in harm's way. (Courtesy of State Archives of Florida.)

As early as 1858, some cattle ranchers sought to improve the quality of their native cracker cattle herds by crossbreeding with the Brahman bull, a breed from India that was resistant to drought and disease. However, many Kathleen area cattle raisers were dead set against crossbreeding until the idea gained wider acceptance in the 1930s. (Author's collection.)

The prosperous cattle industry in the Kathleen area and throughout Florida suffered a major economic setback in the early 1900s, when Texas cattle tick fever entered the state via cattle from other states. The parasite caused a blood infection in cattle, which led to weight loss and eventual death. Quarantine measures and prohibition of interstate shipping of cattle was ordered throughout the infected areas. The Florida legislature also passed a law in 1923 requiring every cattleman in the state to comply with a tick eradication program, which included dipping cattle in vats filled with an arsenic solution every two weeks. The program's slogan, as shown on a 1920 US Department of Agriculture publication, was "Every Dipping Vat is a Canal to Prosperity." (Courtesy of US Department of Agriculture.)

Cattle dipping vats included a trough approximately 30 feet long, seven feet deep, and three feet wide, filled with the arsenic solution. Cattle were prodded to run through the vat for application of the solution to eradicate the ticks that caused the blood infection. Polk County had more vats constructed (165) than any other county. Area families who constructed vats included Bridges, Bryant, Combee, Costine, Hancock, Keen, Prine, and Raulerson. The arsenic residue that still remains in the ground today from the dipping practice is now known to be a public health and environmental risk. (Courtesy of State Archives of Florida.)

Not all cattle raisers were in full support of the mandatory dipping for tick eradication. This 1933 letter to the state veterinarian references that "six calves have been killed, said calves were mine and my boys. I also noticed that the hide of one cow was blistered caused from dipping." Regardless of the concerns, the fever tick problem in cattle was under control by the mid-to-late 1930s. (Author's collection.)

In 1888, Henry Sidney Galloway (1847–1914) planted what was then an experimental crop of strawberries in the community that would become known as Galloway. By the end of the first season, he made a $600 profit. His sons, Huron H., shown above with his wife, Selma Pierce Galloway; Walter, at right; and Bunn, soon became involved in the strawberry business as well. Many other Kathleen area residents then began growing strawberries, resulting in the Kathleen area becoming known as the "strawberry capital of the world" well in advance of nearby Plant City, which claimed the title in later years. (Above, courtesy of Dorothy Galloway Hollis; right, courtesy of Geraldine Galloway Randle.)

The Huron H. Galloway strawberry-packing shed pictured above was located in the community of Galloway. The shed served as the model for a sketch pictured in the award-winning 1945 children's book by Lois Lenski, *Strawberry Girl*, about the strawberry culture in the Kathleen area. At the gable end of the strawberry-packing shed, below, was the H.H.G. Galloway stamp, which was used on crates of strawberries shipped from the area. Until refrigerated railcars came into existence, a sheet of galvanized metal was laid on top of each crate, ice was placed on top, and the entire package was sealed tightly with a lid. (Both, courtesy of Dorothy Galloway Hollis.)

The Alonzo (1877–1970) and Eliza (1880–1964) Robbins family, pictured above around 1916, and Lou Wheeler and Lizzie Chestnut Perkins (1891–1982) of Griffin, below, were typical of the numerous families who engaged in strawberry farming in the late 1800s and early 1900s in the Kathleen area. After picking, the fruit was spread on burlap fabric for washing and sorting. (Above, courtesy of Kathleen Area Historical Society; below, courtesy of Carlton Phelps.)

In this 1914 photograph of "the Gandy place," along present-day West Socrum Loop Road in Socrum, Granvel Lee Bryant (1866–1923), in the dark coat, is holding a gun, a common accessory in strawberry fields to guard against robins and other birds that were a constant threat to the ripening berries. The shipping crate at front left is stamped "Boston Strawberry League," which illustrates the lucrative markets available when rail lines were established in the Kathleen area. (Courtesy of Ruth Ann Witter Maloy.)

The Lanier family of Providence is pictured in their strawberry field around 1915. From left to right are Ethel Lanier and her husband, Cleve Lanier, with daughter Louise in the foreground, Lizzie Lanier, John Roberts, and J.W. Lanier. (Courtesy of Harvey Lanier.)

Strawberry farming was a family and community enterprise, involving multiple families who helped one another with crop responsibilities. Members of the Wilder, Lanier, Rushing, and Witter families are shown here in the Socrum/Providence area in the early 1900s. When the berries began to bloom in late October or early November, pine straw was collected and deposited between the rows to cover the plants when freezing weather was imminent. When the freezing temperatures passed, the pine straw was removed. (Courtesy of Melba Roberts.)

Members of the Wilder and Costine families along Wilder Road in the Providence area proudly display their containers of strawberries in their strawberry packing shed, against the backdrop of a large strawberry field in the early 1920s. At left is Edward T. Wilder (1870–1931). The woman wearing the hat is Della Brown Costine (1880–1963) and next to her is Ida Mizell Wilder, wife of Edward T. Wilder. (Courtesy of Melba Roberts.)

Above, the W.E. Ballard family of Galloway illustrates that strawberry farming was a family affair and included infants and toddlers, teenagers, adults, and the family dog. Children were often relied upon to shoo away birds that were attracted to the berries. Below, a farmer and his daughter are shown in their strawberry field in Providence. Farmers also grew other row crops like sweet potatoes and cabbage, visible at right. (Above, courtesy of Becky Hardaker Elliott; below, courtesy of Robbie Woodham Miller.)

The Fentons, pictured here around 1928, were a Socrum area family who grew strawberries. Third from left is Wretha Hancock Fenton with her husband, Andrew Fenton, second from left. The others are unidentified. (Courtesy of Harvey Lanier.)

Brothers Lum Poston, left, and Crock Poston, right, were both Galloway area strawberry growers. A cousin, Washington Poston, sits between the brothers. The town of Plant City, in neighboring Hillsborough County, eventually surpassed the Kathleen area in strawberry production after farmers there organized a co-op. (Courtesy of Marjorie Poston Butler.)

The first Marsh seedless grapefruit originated on the Socrum farm of William H. Hancock (1823–1900). He purchased land in Socrum in the early 1860s from Belinda Futch Rushing, who is credited with planting the seedling that became the parent of the Marsh seedless grapefruit. A nurseryman in Lakeland, E.H. Tison, recognized the commercial value of this seedless variety and included it in his price list of the Lakeland Nursery in 1889. Tison eventually sold his nursery to C.M. Marsh, who later distributed the variety under his name. Hancock and his wife, Calistianne Strickland (left), are pictured with the family around 1890. (Courtesy of Phyllis Mallory Kendrick Hammond.)

A much-needed tool in area citrus groves at harvesttime were these ladders, made especially for citrus grove use. The tall ladders were usually made of cypress and designed with a wider base at the bottom for additional stability. (Courtesy of State Archives of Florida.)

Almost every family cultivated a few citrus trees or an entire grove in the early 1900s. In 1917, Polk County shipped more than one million boxes of citrus each year. Doing their part to meet the demand were (above), from left to right, Rosa Gavin, an unidentified friend from North Carolina who seems particularly interested in the fruit, and Celeste Gavin. Pictured at right are John C.F. Witter (1858–1953) and his wife, Hattie McCaskill Witter (1862–1951), posing in their orange grove in Socrum around 1920. (Above, courtesy of L. Rabun Battle; right, courtesy of Ruth Ann Witter Maloy.)

In preparation for freezing weather, area citrus grove owners assembled piles of wood in rows between trees and built fires to keep fruit from freezing, as shown above around 1930. The citrus crops in the Kathleen area and throughout Polk County were devastated by freezes in 1894 to 1895 and again in 1917. (Both, courtesy of State Archives of Florida.)

Many area residents were employed at the Carpenter's Home, a retirement facility for carpenters that opened in 1928 in the Gibsonia Area and closed in 1976. Those pictured here were responsible for the facility's citrus grove operations. Note the gravity-operated gas pump on the left, over the shoulder of one of the workers. (Courtesy of Kathleen Area Historical Society.)

Many families attempted to grow bananas, but the crop was not as successful as citrus, strawberries, and other row crops. This banana farm was located along Banana Farms Road (now Banana Road) in the Providence/Socrum area and was a short-lived endeavor. A freeze destroyed the crop tended to by Wilburn Bryant "Bud" Harp (1903–1952), at far left. A few surviving banana trees can still be found on Banana Road. (Courtesy of Patrick Lombardi.)

The communities of the Kathleen area diversified the agricultural economic base in the late 1800s and early 1900s, primarily through the logging and sawmilling industries, continuing the tradition of living off the land. Above, Council Brown stands between the two mules, surrounded by piles of sawdust and other sawmill workers in the early 1900s. Below, members of the Bryant family, including David Rufus Bryant (1855–1912) and Rufus Bryant (1880–1948), are pictured taking a break from logging. (Above, courtesy of State Archives of Florida; below, courtesy of Robbie Woodham Miller.)

Turpentining operations were especially prevalent in area communities from around 1900 to 1925. A resin substance extracted from trees was used to create a variety of products, including turpentine—an ingredient used in soaps, cosmetics, and paint. As shown above, a cut was made on the trees, known as a chevron or cat's face, to facilitate the extraction of the resin by turpentine workers, who were predominantly African American. (Both, courtesy of State Archives of Florida.)

Turpentine mills were scattered across communities and were especially active near Green Pond and Kathleen. By 1925, most mills had ceased operations. (Courtesy of State Archives of Florida.)

The Strickland Lumber Mill in Kathleen was a busy center of activity and commerce in the early 1900s until a severe windstorm in the early morning hours of March 25, 1909, caused significant damage to the business, blew down "several negro houses and a negro church," and resulted in the death of one employee, R.E. Zoucks, a cooper who was sleeping in the commissary at the time. (Courtesy of Harvey Lanier.)

Railroads and rail lines also boosted the logging industry, as shown in these photographs from the early 1900s. In the town of Kathleen, the Strickland Lumber Company set up business around 1903 near the Kathleen rail line and operated for several years. The company employed many local residents and platted land (the Strickland Lumber Company subdivision), upon which housing was built for company employees, like that shown below. (Both, courtesy of State Archives of Florida.)

Sugarcane grinding and syrup-making was undertaken in the fall and was both an economic necessity and a social event. Neighbors helped neighbors cook down the juice in large cast iron pots to produce syrup and store it for the winter months to serve on hot biscuits or pancakes. Above, Roscoe Costine (1891–1962) is pictured holding a child, surrounded by family and friends. Below, William Hiram Chestnut (1850–1939) and family are shown with sugarcane and the required tools of the trade, including the horse to power the cane grinder. (Above, Author's collection; below, courtesy of Patrick Lombardi.)

Six

MULES AND WAGONS, VELVET ASPHALT, AND TIN LIZZIES

According to this August 27, 1887, correspondence to W.H. Costine (1856–1942), the "Celebrated Macy Wagon," a buckboard, could be had for $50 cash from George E. Macy, a wholesale manufacturer located in Orlando. Macy notes that the buckboard is usually sold in Orlando for $55 but since the potential buyer is "so far off" in Lakeland, a special offer is extended. (Author's collection.)

A fine surrey and a good horse provided transportation for "courtin'" for some area couples, until marriage and children required more practical transportation like a wagon and mule. Ed Bridges (1882–1969) and his soon-to-be wife, Emma Jones (1887–1948), are pictured above around 1907. The Bridges family settled on Banana Road in the Providence/Socrum area, where the couple raised four sons—Edgar, Hollis, Jesse, and John—who are pictured below astride the family mule. Bridges operated a sawmill, and his wife was known far and wide for her noontime feasts, prepared fresh from the couple's garden. (Both, courtesy of Glenn and Patsy Flora Bridges.)

A good mule provided dependable transportation to these two young men before automobiles became widely available and affordable by 1920. Note the tent in the background, possibly used as housing for logging operations. Pictured are Ebo Tilton (left) and Clark Gavin (1895–1958). (Courtesy of L. Rabun Battle.)

The Cason family of Socrum relied on their wagon and a bicycle for transportation. From left to right are Clark Cason, William G. Cason (1862–1920), Eunice Cason, Laura J. Holloway Cason (1872–1948), Nancy Cason, William Cason, John Cason, unidentified, and Fiddler the dog. (Courtesy of State Archives of Florida.)

By 1919, Polk County's Good Roads Association bond issue had resulted in a system of 217 miles of "velvet asphalt" roads and included a segment between Kathleen and Lakeland. The segment, pictured above, was in the Galloway community. Pictured below is a segment through the Socrum community. The Texaco asphalt pavement was laid by the E.C. Humphrey Company. As with turpentine operations and rail lines, a major portion of the labor force for road construction was comprised of the area's African American population. (Both, courtesy of State Archives of Florida.)

The E.C. Humphrey Company of Hackensack, New Jersey, established an asphalt plant in Kathleen after being awarded a portion of Polk County's $1.5 million road bond issue to build 217 miles of roads in 1918. In an April 1918 issue of *The Earth Mover*, an article entitled "Lifting Florida Out of the Sand" references the company being awarded the contract for 44-and-three-quarter miles of roadway construction in Division 4, "Scorum [sic] to Lake Wales via Kathleen, Griffin, Lakeland, Medulla, Mulberry, Bartow to Lake Wales." Prior to road construction, the area relied on "impassable roads, which frightened away settlers, caused automobile tourists to make wide detours to avoid the county, and seemed productive of nothing but profanity." The article predicted that the completion of the contract "will give Polk County the finest system of roads in the south." (Courtesy of State Archives of Florida.)

Even after automobiles became widely available, families still relied on a horse or mule to power the sugarcane grinding and syrup-making operations. Shown here around 1916 is the James W. Lanier family of Providence. From left to right are Susan Lanier holding Verna Roberts, Mary Roberts, Hettie Lanier, Dallas Lanier, John Roberts, Sarah Sherouse Lanier, and James W. Lanier. (Courtesy of Harvey Lanier.)

Once asphalt-paved roads were completed, some area residents purchased automobiles and often included the vehicles in family photographs, an indication of pride of ownership. In the above photograph, taken around 1926, Gladys Costine Flora (1917–2011) is behind the wheel, with her Brown cousins, (from left to right) Maynard, Park, Herbert, Cleveland, Annie, and Jack (kneeling) assembled on the running board with the family dog. Below, Audubon G. Brown (1897–1973) strikes a proud pose with his family. (Both, courtesy of Patsy Flora Bridges.)

An unidentified family awaits a fill-up for their Ford Model T at a filling station in Winston in 1920. At the time, a gallon of gas cost about 20¢. Though initially cost-prohibitive, Model Ts ("Tin Lizzies"), were mass-produced by Ford Motor Company between 1913 and 1925, which resulted in the car costing less than $300 by 1925. (Courtesy of State Archives of Florida.)

Kathleen resident Kenzie Cockrell (1885–1961) is pictured behind the wheel with, from left to right, his wife, Mattie, Lois Gavin, and son J.K. Cockrell. Cockrell was a section foreman for the Atlantic Coast Line Railroad. (Courtesy of L. Rabun Battle.)

The Lanier family is pictured with their "Copperhead" Model T around 1916. Family members are, from left to right, Susan Lanier holding Verna (Lanier) Roberts, Lizzie Lanier, Louise Lanier, Ethel Lanier, Jim Lanier, and Cleve Lanier. The Lanier family was prominent in the Kathleen and Providence areas. (Courtesy of State Archives of Florida.)

Ida Mizell Wilder (1876–1956), her son Edgar, and her husband, Edward T. Wilder of Providence, are seated on the running board of their car around 1919. (Courtesy of Melba Roberts.)

A.W. "Babe" Costine (1884–1973) pumps gas into his 1924 Ford touring car, while his daughter Gladys Costine (Flora) looks on. The young boy by the pump is Costine's grandson Billy Foshee. Costine wears a sleeve garter just above the elbow, a practical men's accessory of the day, necessary when long-sleeved shirts came in one extra-long length. The garter served to adjust the sleeve length and to keep cuffs from becoming soiled. (Courtesy of Patsy Flora Bridges.)

1930 Registration Card 1-17-30		Tax Collector Certificate No. 6521	
Date 2-4-30	Tag No. 267-797	Tax $ 8.00	
Name Ford	Type Touring	Back Tax $	
Engine No. 6343557	Capacity 5	Pas. Lbs. Use	Pri
Serial No.	Tires Pneu	Date acquired 1924	
Weight 1600	Yr. Make 1922	T. C. No. 116833	
Co. Polk			

FLA

W. H. Costine
Route #4, Lakeland
FLORIDA

1930

W. S. McGinn Acting Motor Vehicle Commissioner. (OVER)

Babe Costine's father, W.H. Costine, also owned a Ford touring car, a 1922 model as illustrated by this 1930 tag registration card. (Author's collection.)

Celeste Lovejoy (1902–1975) married Clark Gavin in 1920 and lived in Kathleen. The couple was the proud owner of this Model T. (Courtesy of L. Rabun Battle.)

Though Henry Ford put the world on wheels in 1908, the Chevrolet Motor Company brought competition to the industry by 1911. Galloway resident Lum Poston (1885–1984) preferred the Chevrolet brand in this 1920s photograph. The iconic Chevrolet "bow tie" emblem, introduced in 1913, can be seen on the front of Poston's car. (Courtesy of Bernice Poston.)

Percy Hardaker (1901–1974) and wife, Lucille Sumner Hardaker (1906–1992), sit on the sideboard of their car around 1926. The couple operated a general store in Kathleen at the site of the present-day Lions Club building. Hardaker also served as the Kathleen postmaster in the 1930s and again in the early 1960s. (Courtesy of Becky Hardaker Elliott.)

Grocer John W. Lanier is shown behind the wheel of his modified vehicle in 1918, which allowed transport of goods for his grocery business. Lonnie Wright stands in front. Note that Lanier is wearing a grocer's apron. He was born and raised in the Providence area but moved to Lakeland to be closer to his grocery store, located at the northeast corner of Tennessee Avenue and Pine Street. (Courtesy of Harvey Lanier.)

These four young men appear to be dressed and ready for a night on the town, though there does not appear to be any room for their dates. From left to right are Clark Gavin, Ebo Tilton, Charlie Ross, and unidentified. (Courtesy of L. Rabun Battle.)

About the Organization

Around 1988, three women who were born and raised in the northwest Polk County community of Kathleen were responsible for the idea of establishing a nonprofit organization to preserve and promote the area's dwindling history and heritage.

Many of the old houses and barns had been destroyed by this time in one manner or another; pictures of many families and points of interest had been lost forever, tools that our farmers used to till the land were rusting away, and new residents were unaware of area history.

These three women were Hilda Gavin Battle, Becky Hardaker Elliott, and Doris Stalvey Glisson (great-granddaughter of Kathleen pioneer Henry Prine). Betty Ann Williams, a former Kathleen area schoolteacher at Winston, Griffin, and Kathleen, soon joined forces with these three determined ladies, and on March 25, 1991, the nonprofit Kathleen Area Historical Society was created.

Now in its 24th year, the Kathleen Area Historical Society sponsors events and activities throughout the year, both as fundraisers and as celebrations of the heritage of the Kathleen area. All events are held at Heritage Park, located at 8950 North Campbell Road in Socrum.

A portion of the proceeds from sales of *Communities of the Kathleen Area* will be donated to the society.

Discover Thousands of Local History Books Featuring Millions of Vintage Images

Arcadia Publishing, the leading local history publisher in the United States, is committed to making history accessible and meaningful through publishing books that celebrate and preserve the heritage of America's people and places.

Find more books like this at
www.arcadiapublishing.com

Search for your hometown history, your old stomping grounds, and even your favorite sports team.

Consistent with our mission to preserve history on a local level, this book was printed in South Carolina on American-made paper and manufactured entirely in the United States. Products carrying the accredited Forest Stewardship Council (FSC) label are printed on 100 percent FSC-certified paper.

MADE IN THE USA